ART-DIRECTING
PHOTOGRAPHY

ART-DIRECTING
PHOTOGRAPHY

HUGH MARSHALL

PHAIDON · OXFORD

A QUARTO BOOK

Published by Phaidon Press Limited
Musterlin House
Jordan Hill Road
Oxford OX2 8DP

First published 1989

Copyright © 1989 Quarto Publishing plc

A CIP catalogue record for this book is available
from the British Library.

ISBN 0-7148-2600-6

This book was designed and produced by
Quarto Publishing plc
The Old Brewery, 6 Blundell Street
London N7 9BH

Senior Editor Cathy Meeus
Editor Lydia Darbyshire

Design Tony Paine
Picture Research Simon Jones, Arlene Bridgewater

Art Director Moira Clinch
Editorial Director Carolyn King

Typeset by Ampersand Typesetting, (Bournemouth) Ltd
Manufactured in Hong Kong by
Regent Publishing Services Ltd
Printed in Hong Kong by South Sea Int'l Press Ltd.

Y0012694

CONTENTS

INTRODUCTION

WHY A PHOTOGRAPH ANYWAY? Why not an illustration? Why not some dramatic typography? Well, of course, it's not that simple. Apart from the fact that your client may have specifically requested photographs to illustrate the job in hand, a photograph is often the *only* satisfactory solution. Imagine, for example, a travel brochure full of pencil drawings of sunny resorts, a cookbook full of watercolours of those delicious dishes, a mail order catalogue full of line drawings or an oil painting of the new ZX Turbo? Of course, all these illustrations would be beautiful, but would they create the effect that you are looking for?

THE IMPACT OF PHOTOGRAPHY

What then is this special quality that the right photograph can bring to graphic design? Is it the ability to describe, to convey atmosphere, to entertain, to make an artistic statement or to sell a product? The commercial photograph can do all of these things. The reader already knows that the sparsely inhabited Caribbean holiday resort is likely to have silver beaches fringed with palm trees and a sea coloured every shade of blue imaginable, all bathed in permanent sunshine. But did it ever look as enticing as in *this* photograph! The reader may also know what a soufflé looks like and, indeed,

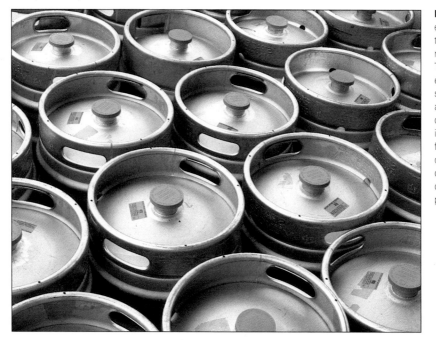

■ **Left** A mass of similar objects, even if the shapes are simple as in the case of these steel drums, can make a bold image in photography. The strengths of this uncomplicated example are that all distracting surroundings have been excluded and the camera angle creates a diagonal structure. Cropping – that is, adjusting the viewpoint or the focal length of lens to trim the edges of the image – and ad hoc composition, both fundamental camera techniques, can be used to produce this type of effect.

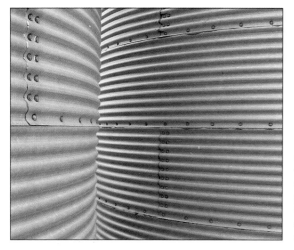

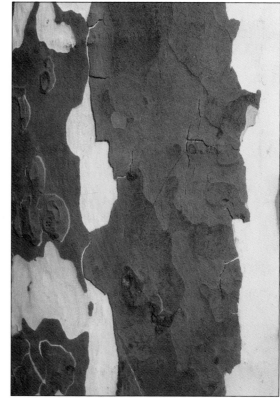

may have cooked many. But doesn't *this* photograph make it look so delicious! And the way that raspberry coulis is oozing from the centre – it's so mouthwatering! Most important though, it is a photograph so it *must* be real, even though the reality may be an idealized fantasy.

It is this reaffirming of a dream, whether attainable or not, which makes the role of a commercial photograph so important. But the job of a photograph is not just to depict a familiar scenario such as the holiday resort – it must also surprise and inspire, leading the reader with confidence into an original and unfamiliar concept, whether it be trying out a different recipe or splashing out on the latest fashion or newest car.

UNDERSTANDING THE PHOTOGRAPHIC MEDIUM

The partnership of graphic design and photography has been instrumental in creating some of the most outstanding examples of applied pictorial art produced this century. For this partnership to be a success, the art director must be aware of the potential and limitations not just of the medium of photography, but of the photographer and of every other person involved in the shoot. It is important that you have a pretty thorough technical knowledge of photography – after all, you'd be wasting

■ **Left** At first unpromising, this industrial subject has been turned into an abstract design that makes use of linear perspective, curves and light.

■ **Right** In a close-up photograph of the bark of a tree, texture, shape and colour are balanced in another partially abstracted photograph. Used like this, the camera selects designs from the real world, without contrivance or deliberate placement.

■ **Below** This pattern of arches is naturally modulated by natural daylight from above. By raising the camera, the photographer has made the patterns the sole subject and not just an integral part of the room.

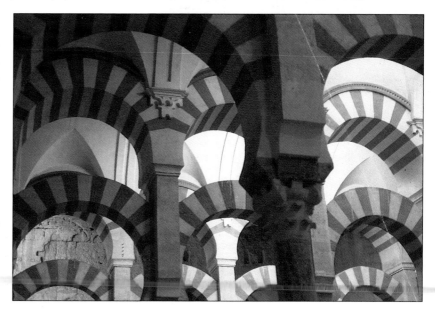

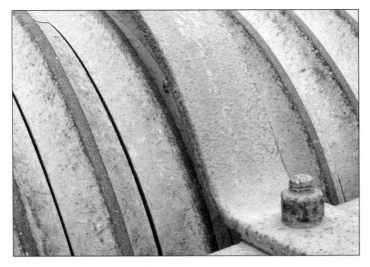

everybody's time (and money) if you insist on a shot that simply isn't technically possible.

In order to develop a feel for the photographic image you should take photographs as part of your daily design routine; just as an illustrator keeps a sketchbook, so you as a designer should train your eye to look at shape, texture and colour by taking photographs.

When building up this visual record, look at patterns formed by cast shadows repeating the image when falling on flat surfaces; the exciting forms of iron and metalwork on buildings, images sharpened by lighting, familiar objects rendered abstract by close-up focus, isolating them from their environment. The texture of rusting metal on smooth stones; shape formed into silhouette by back lighting. The bark of a tree; the curve of a bridge over a river; colour, strong against light, rich and crusted on a building.

Shape and spatial relationships relate directly to composition. Pictures are formed by using static and dynamic forces. A static shape is a circle or square. Dynamics is concerned with movement; lines and rectangles, which are described as being directional, fall into this category.

Practise looking for ways of guiding the eye into the picture through diagonals, perhaps formed by paths or walls, which create dynamic effect. Having

■ **Left** The contrast of colour and tone between yellow (which always tends to advance strongly in a picture) and black helps to make this a striking and unusual image.

■ **Above** Spacial contrast can be created by a simple treatment as in the photograph above where one object – a nut – is placed eccentrically in the frame so that it is clearly opposed to the larger area of curving lines.

■ **Left** Curves tend to produce a strong sense of order in an image as this downward view of an exterior staircase. By selected the viewpoint with care, so that the curves are at different angles, the photographer has introduced a dynamic element.

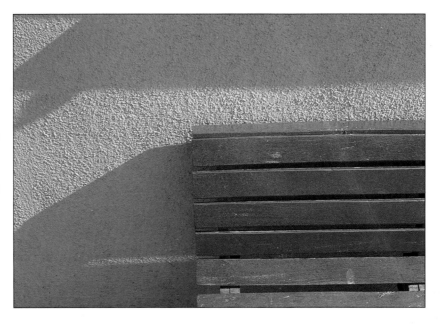

■ **Right** Colours can themselves be an eye-catching subject for a photographic image as in this photograph of a bench against a painted wall. Note how there is even an optical vibration at the edge where the blue and red meet. The photographer must use the camera to isolate the colour areas selected for this type of image.

taken the eye into the composition try to find shapes that will create a focal point or heart to the picture. In most cases you will be working in a square or rectangle and your concern is how best to divide the area and position the shapes within it. Deliberate asymmetry can be a device to create a special effect and provide drama to the visual image.

You should also make yourself familiar with ways of creating atmosphere – for example, use of tonal relationships and colour and by lighting, weather conditions, style of composition, precise choice of subjects. A still life can be given a warm country look by use of soft gentle tones of brown, yellow and green with low lighting. In contrast a cityscape with bright, shadow-forming lighting and harsh colour will soon convey the busy street and nervous energy of a metropolis. Tonal formation is as vital to a composition as is a structural framework.

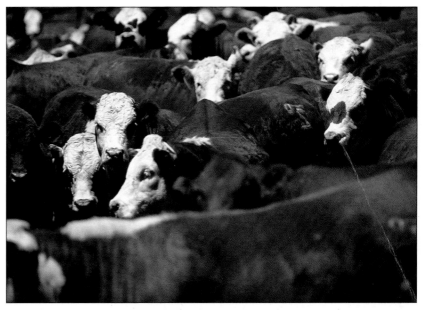

■ **Above** In contrast to painted man-made objects which, as in the picture at the top of the page, are often in bright hues, most of the large scale colours of nature are subdued. Browns, greys and dull greens predominate. Modern colour films are particularly successful at recording subtle variations in such hues as in the range of browns in this herd of cattle.

So how can you apply this direct experience of using the photographic medium to improve the use of photography in your designs, when obviously you won't be taking the pictures yourself? The main benefit is that you should feel better qualified to select the right photographer and to provide an effective brief. The success of a project often depends on the rapport that is created between art director and photographer.

Although you may think you know what you want, always be flexible and allow yourself to change your ideas. Never ignore the ideas of the photographer (after all, that's what you're paying for), nor should you ignore or reject the possibility of chance presenting you with the shot of a lifetime,

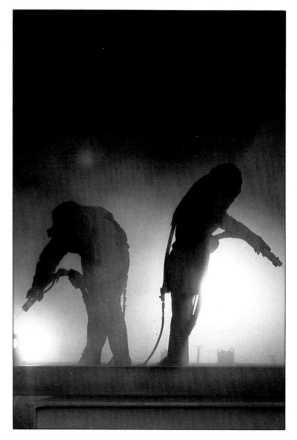

■ **Below** Lighting is the key to a great deal of successful photography. In this photograph, raking light from a low sun in a clear sky brings out the textures in the leaf and ground.

■ **Right** Lighting used in an unconventional way transforms the prosaic work of two sand-blasters into a mysterious and atmospheric scene. Back-lighting – shooting into the light source – can simplify images and create silhouettes.

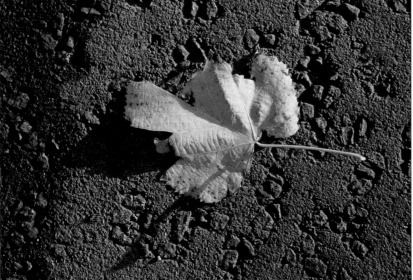

no matter how many hundreds of hours went into a military-style planning campaign. The interaction of ideas between the two disciplines can be a very rewarding experience, and it is important for the designer to be receptive to new and sometimes unfamiliar concepts.

As for the rest of your job as art director, this book will give you valuable advice and insight into the creative, organizational and technical role of the art director in producing photographic images of different subjects for a variety of graphic design applications.

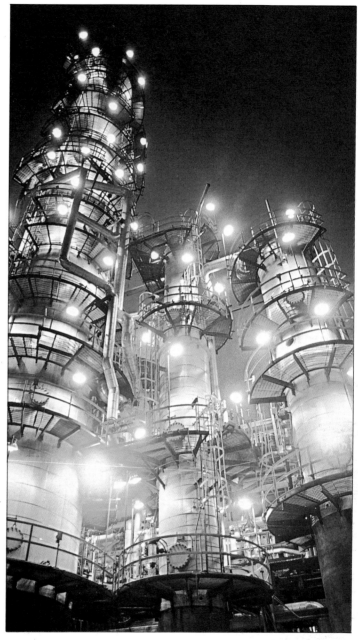

■ **Right** Artificial light sources have spectra that differ substantially from that of sunlight. Mercury vapor lights which illuminate this oil refinery produce a striking blue-green glow on film, which the photographer has used here to good effect by shooting close-up with a wide-angle lens so that the lights fill the frame.

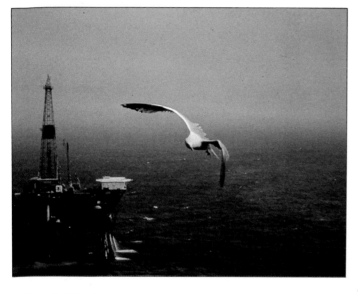

■ **Above** Oil-drilling platforms are such widely photographed subjects that there is a premium on any shot that contains an element of surprise. Here the presence of the seagull is striking – at once establishing depth and perspective, while reinforcing the bleak isolation of the rig.

SECTION ONE

PREPARATION

AND

PLANNING

PREPARING
THE BRIEF

A CLEAR AND LOGICAL APPROACH is essential in art directing photography to a particular brief. There are several factors to be considered: how to select the appropriate photographer or image; how to formulate the creative brief; and how to manage the actual shoot to keep within budget and to schedule. As art director, you will be responsible for controlling the cost, finished format and timing to meet your deadlines. The proper amount of forward-planning is vital, and can be achieved if you follow the guidelines discussed on the following pages.

THE BRIEF

There will be an initial meeting with the client, when the brief for the assignment will be fully discussed and any aspects that should receive special treatment or emphasis are noted. Your task now is to give visual expression to the verbal brief. Ideas will be drawn and rejected until a visual style and image can be worked up to a form in which they can be shown to the client for approval, or, further requirement or alteration. If more than one image is required and a sequence of photographs involved, a visualizer should be asked to prepare a storyboard and layout.

INTERPRETING THE BRIEF

As art director, you must now decide what will fulfil the client's wishes and expectations in the most creative and satisfactory way. If photography is decided on, you will need to have a clear idea of how the photographs are going to be used. You may be working for a client who has the final say, or for an editor who decides if the style of your chosen photograph is in keeping with the publication's editorial policy. In either case, a written brief for photography can be helpful in clarifying your own thoughts, and the understanding of your colleagues and the chosen photographer.

Try to summarize in a paragraph exactly why you require the photographs. They may, for example, be required to complement a rather dry article. An interview with a personality could, perhaps, be interspersed with pictures past and present to bring to life the chronology the writer is following. An advertising brief, on the other hand, is likely to be much tighter in its execution. You will often have to convey a strong idea of a product's benefits in a single page – you will rarely have the luxury of a run of pictures, so every detail will count. The client may insist on a pack or product shot for purposes of consumer recognition, and this may be outside your brief for the main image, so a combination of, for example, location and still life photography may be necessary. This will mean briefing two different photographers and two creative teams, and you must make sure that they both have the same full and written brief. Imagine a new wine on location appearing in a different coloured bottle in a pack shot, because the still life photographer used a coloured filter.

The current trend in art directing fashion catalogues is to use different styles of photography to give each section a "lifestyle" feel. You may find it useful to write a paragraph for the photographer about who you want the catalogue shoppers to

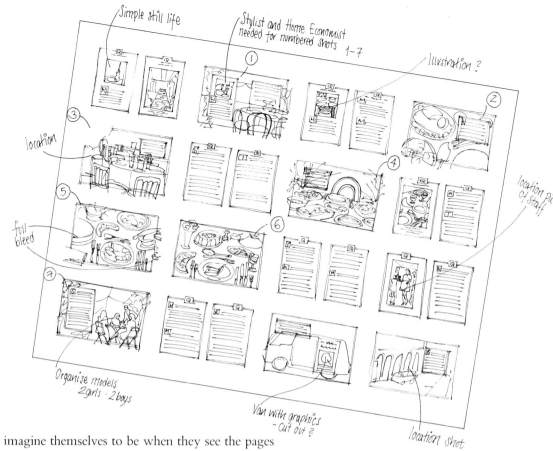

Simple still life

Stylist and Home Economist needed for numbered shots 1-7

Illustration?

location

full bleed

Organise models 2 girls · 2 boys

Van with graphics - cut out?

location shot

location pic of staff

■ **This page** At this stage in the progress of a design brief, the layouts with their anticipated images are roughly sketched. These help to give an idea of the visual spacing, and can also serve as a compositional guide to the photographer. The amount of detail in the rough sketches will depend on to what extent the photographer is expected to interpret, or follow, them.

imagine themselves to be when they see the pages for each different section. A similar approach is also suitable the first time you do magazine fashion or beauty work with a photographer. Your audience may be clear in your mind and in your client's or editor's mind, but a photographer will not always be able to guess this from the magazine's pages or from the product.

The next logical step towards coming up with the perfect use of photography is to prepare a visual of the desired page layout. This gives the whole team of writers and visually creative people an idea of how their work is going to be balanced. It can also save a lot of later conflict over the size and shape of pictures and the delicate subject of cropping. Sometimes the pictures lead the way, and a copywriter uses the visual inspiration after your shoot to come up with his line. More often though, the written context is very important for the strongest use of photography.

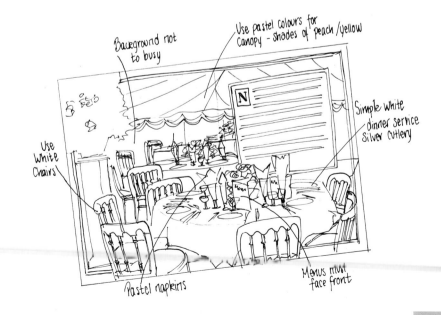

Background not to busy

Use pastel colours for canopy - shades of peach/yellow

Simple white dinner service silver cutlery

Use white chairs

Pastel napkins

Menus must face front

Library or commissioned

ONCE YOU HAVE WORKED OUT the details of your visual and written brief, you will be able to decide if commissioned photography is likely to be the best solution and if it is within your budget. When you commission a photographer you are not only buying the services of the one person whose style you have admired and think suitable, but also a back-up team of professionals. Commissioned photography is both costly and labour-intensive, and it is vital not to get caught out with unexpected extras. The extra people who are involved in

photographic sessions of various kinds are discussed in a later section, and you must make sure that you keep up-to-date information about the numbers, likely additional timing and costs that will be incurred in a variety of circumstances.

In view of the cost of commissioned photography, you may elect to look for suitable photographs from alternative sources such as picture libraries.

USING A PICTURE LIBRARY

You may already have extensive records about picture libraries on file, but if your departmental budget permits it, a good picture researcher or editor is invaluable, provided they are well briefed by you so that they come up with images that are in your chosen style. You should, for example, show them your collection of tearsheets.

If you have to contact the picture libraries yourself, the best way of learning how they operate is to contact the British Association of Picture Libraries (BAPLA), to which most of the leading UK libraries are affiliated and which publishes a list of its members' specializations. The libraries usually require a search fee, in return for which they send a selection of the work they have on file.

It is essential to give the picture libraries the broadest possible brief. If, for example, you ask for a particular bridge in France to illustrate a travel article, you are less likely to be supplied with a wonderful picture than if you ask for a selection of photographs of the region. Different picture libraries interpret requests for pictures in different

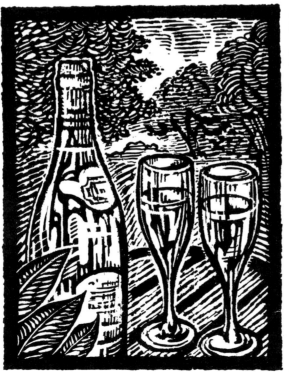

■ **Right** Although in most advertising and the presentation of commercial products photography offers the most realistic version of a branded object, illustration can be more flexible and can offer a style that cannot be achieved photographically, as in this woodcut.

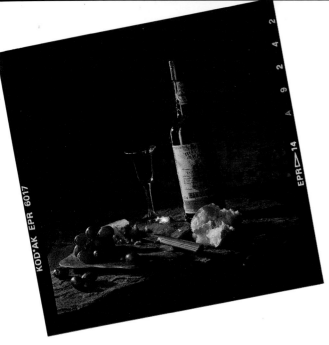

■ **This page** Once photography has been decided upon as the way of displaying the object, the next major choice is between an individually commissioned shot (**left**) or a stock photograph (**below left**). Stock images are mainly available from picture libraries, which collect shots that have been produced either as part of previous (often editorial) assignments or in anticipation of stock use. Stock photography has the advantage that, if the photographs are suitable, they are likely to be cheaper than commissioning and exist already.

and make sure that the library or photographer signs the letter.

Finally, remember to check with the library exactly what their charges are for the use you require. If you use the image in a large poster format as well as on a double-page spread in a magazine, you will probably be charged separately for each usage. Similarly, the costs of reproduction rights for the home and international markets will vary widely. The library or agency is within its rights if it later charges you an extra fee because you have exceeded your original agreement.

Picture libraries are, however, suitable only for certain areas of photography. Your requirements for subjects such as landscape, travel, animals, plants, food and drink, stately homes, sport, personalities and members of the royal family, the theatre and dance, architecture and historic images might be met by picture libraries and similar agencies, but other areas, like fashion, beauty and, increasingly, interiors, rely for their success on being up to the minute. As they feature new products and styles, they must be shot afresh and exactly to your brief.

Buying in a picture from a library may solve your creative objectives, and it is cheaper than commissioning new photography. However, this solution will always be a compromise, and it is important to check with the library or photographer involved if you have exclusivity on the image – at least until your choice appears in print. There is nothing worse than seeing the image you have so carefully selected being used simultaneously by a rival magazine, advertising agency or catalogue.

ways, and it is worth developing a good contact in a specialist agency, especially if you regularly need images in a costly area of photography such as travel and you are working to a tight budget.

Make sure that you draw up a brief standard letter that you can always use when buying in a picture. Insist on exclusive use of the picture for between two and four weeks either side of your printing date

Finding the right photographer

IF YOU DECIDE THAT COMMISSIONED PHOTOGRAPHY is the best solution, you will need to select a photographer. These are many ways you might find someone suitable, ranging from a recommendation from a fellow designer to an entry in one of the directories that are published annually.

During your work, you should build up reference files of tearsheets and photocopies from magazines and books that you like. International magazines can be a good source of inspiration, as they break away from the normal run of magazines you see every day. Some magazines feature the work of new, young photographers. Look at both the advertising and editorial pages and decide why you like a particular approach, whether it be black and white or colour photography. Is it the lighting that appeals to you or the photographer's own special viewpoint? You will then be better equipped to brief a photographer on why that approach is suitable for your publication, brochure or campaign.

You should also make sure that you have an up-to-date copy of the directories that are published each year. Photographers or their agents pay to have examples of their work included in these annual publications, but remember that the work displayed is only a very small sample of the photographer's portfolio and it may not be current at the time of publication. Nevertheless, these directories are a useful source of telephone numbers and addresses of the photographers and agents whose names you come across as you compile your tearsheet file.

Other good sources of telephone numbers for photographers are the professional photographic associations. These associations also publish year books of their members' best work, and they act as a trade association for many of the top photographers.

The main specialists are the international photographic agencies for reportage work, which syndicate news pictures worldwide.

As it becomes known that you are art directing photography, photographers and agents will send you cards advertising their latest work. It is also a good idea to get your name added to the mailing list of photographic art galleries. Write to them, enclosing your business card, and explain that you may well be in a position to commission work from exhibitors. Details of forthcoming exhibitions are published in the listings sections of all the design

■ **Below** An art director should be able to build up a file of work for future reference from regularly seeing the portfolios of different photographers. The photographer's name card can be clipped to prints, or photocopies of their work.

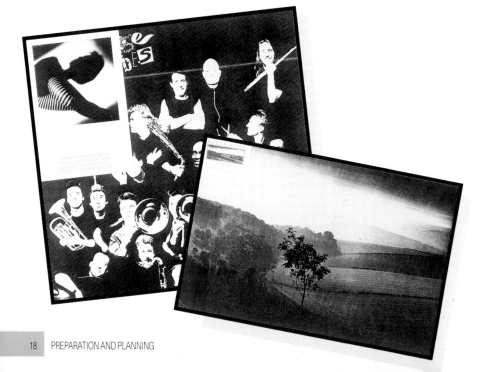

■ **Left** Creative directories provide a source of reference that can be scanned easily and quickly. Ordinary listings in these are editorially compiled, but pictures are paid for by photographers or their agents.

are also listed in design magazines, is another useful way of meeting new talent.

After this ground work you should have a file of photographers whose work you admire and would like to work with in future. Your files will, of course, need constant up-dating as the success of many types of photography depends on how fashionable it is. You must keep your eye in by looking at magazines and books and observing posters and prints of all types.

publications, and this is also a good way of getting to meet your fellow art directors and to learn which photographers they regularly commission and why.

Photographers themselves will also begin to approach you direct for work. This is particularly true of younger people who may not have any published work but who rely on your liking their "test" (that is, uncommissioned) shots, which they will have done at their own expense. Using existing test shots can be an inexpensive way of illustrating a brief, and it is also a way of giving young photographers their first break at a time when they are happy merely to cover their costs and have their work seen.

Even if none of the existing work is suitable, you may see something in the approach that has promise. It is always worth taking the trouble to ask the photographer to do some test shots of a subject more suitable for your needs and to come back in a few months' time.

Attending college end-of-term shows, which

■ **Below** File cards – most to a standard size – are printed up by many photographers and are another useful source of information. It is advisable to keep a wide range of styles on file, to anticipate unpredictable design assignments.

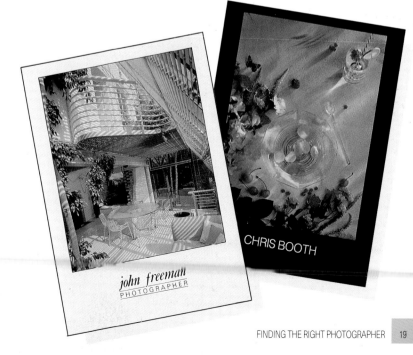

Looking at portfolios

HAVING FOUND THE NAMES OF PHOTOGRAPHERS whose style you like, your next step is to call in their portfolios for a closer look. Photographers at different stages in their career will have different approaches to make to you.

A successful and busy photographer will usually be represented by an agent, who will accompany the portfolio to your office. The best agents are familiar with the photographers they represent and with their working methods, although this is not always the case. Some agents represent more than one photographer, but it is unlikely that agents will represent more than one food photographer, for example, as their clients would be in competition with each other.

If you decide that the work presented is what you are looking for, try to ascertain a day-rate from the agent for future reference. In any case, you should arrange to meet the photographer well in advance of the shoot to make sure that he or she completely understands your brief the first time you work together. If the photographer is so busy that a meeting is not possible, you must speak to him on the telephone before the shoot to confirm all the points that you have written about.

Some photographers do not have an agent but prefer either to send their work round to you on request or even to come round with it in person. A face-to-face meeting is best because you get an opportunity to talk about the photographer's working methods and to find how long it takes him to achieve the finished results you are viewing and any special needs of his particular type of photography. Initially, you may not be viewing the work with a specific brief in mind, but it is important that you give the photographer some idea whether his work is going to be suitable for your creative style. The photographer may have the perfect shot for your purposes in his portfolio, in which case you should turn to the section on buying in photographs! More often however, you will not be able to commission him for some time, and you will, therefore, need to keep a record of the selection of his work that you found interesting. Ask if you can photocopy these shots, take his card so that you know where to contact him again, and file the information in a system that is relevant to your particular needs. Most useful will be broad headings such as fashion,

■ **Below** Although portfolios vary individually, under typical circumstances an art director can expect to see work in this form: a case containing laminated proofs, tearsheets and prints. Unpublished photographs are also likely to be presented as transparencies mounted in card frames.

QUESTIONS TO ASK A PHOTOGRAPHER

■ What do you feel is your speciality?

■ For whom do you normally work?

■ How many shots can you manage in a day?

■ What format do you work on?

■ Do you own your own studio?

■ Do you "package" your day's work – that is, provide a full estimate for all back-up services such as models, hair and make-up artists, location-finders, room set-builders and so on? Or would you expect the art director to do this?

■ Would you be happy to have third parties such as clients or fashion editors on the shoot?

You can probably add many more questions based on your own particular needs, but just by covering these points in a preliminary meeting you can avoid a lot of misunderstandings both in the period leading up to a shoot and on the shoot itself.

still life, cars and so on, and sub-divisions according to technique. For example, a fashion file could have such sub-sections as location, studio, male/female models, children, catalogue fashion, and avant-garde, traditional, lingerie, shoes and accessories. The section on still life could be broken down into food, flowers, bottles, special effects, ice, antiques and furniture. You can then find at very short notice the specific photographic approach that suits your particular requirement.

Viewing portfolios can be a time-consuming business, and you should allocate a specific time each month just for viewing photographers' work. Depending on your own needs, this might be two hours a week with appointments at 30-minute intervals or two afternoons a month in the company of your picture editor. Speculative meetings should be fitted in to suit your diary rather than taking a huge chunk out of each working day.

It is important that you have no distractions when you are looking at photographers' work. Alert your office that you are out of bounds and will not be taking any calls. The experience of comparing several photographers' work within a short space of time can be very enlightening: subtle differences in lighting and technique become immediately apparent. So that you can compile notes for future reference, you should have a typed checklist of questions to ask photographers and their agents.

Studio or location?

THE CHOICE BETWEEN A STUDIO and location shoot is not always clear cut. Building a large set can, for example, be more expensive than the most exotic location trip. At first, you may find it helpful to weigh up the pros and cons in the tabular form shown in the box so that you can clearly see where the benefits lie, remembering to take into account: lighting, any spin-off benefits, cost and timing.

LIGHTING AND THE DESIRED CREATIVE EFFECT

Some areas of photography require an enormous amount of control over lighting. Consumers are used to seeing a "perfect" product in advertisements, and you may be asked to re-create for a magazine the same effect as seen in one still of a television advertisement. Such specialization is best catered for in a studio, and there are even special car studios with carefully constructed lighting coves that ensure perfect lighting results every time.

Surreal or special effects photography is also most successfully treated in the studio. Such results are increasingly achieved by computer-manipulation after the shoot takes place, but this high-technology treatment does not come cheap.

For some briefs, however, a more natural light is required. Portraiture or work for homes and gardens magazines, for example, may be done in the subject's own home, and this low-cost backdrop will give an added insight to the subject when published beside an interview.

For fashion work it is possible to use natural light in a suitable studio, where the natural shadows and sunlight patterns can be a strikingly simple accompaniment to, say, a portrait or dance illustration.

Well-known locations can add an atmosphere that cannot be captured in a studio, however skilful the use of backdrops and projection. No matter if the background is somewhat blurred, notable architecture can lend credibility to a copy line, and it often costs nothing to include a distant building in a shot. Some art directors build up a file of suitable locations, and note potential features whenever they come across an interesting townscape or unusual scenery.

Transport can be a problem, and each member of the team should bring some items to the site –

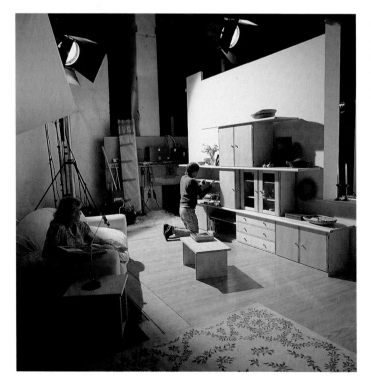

■ **Below** Because it offers conditions that are completely controlled, the studio is the most frequently used setting in commercial and advertising photography, where briefs are usually very specific. A partial room set like this is the only practical method of photographing large immobile objects like furniture, even though the space needed is considerable.

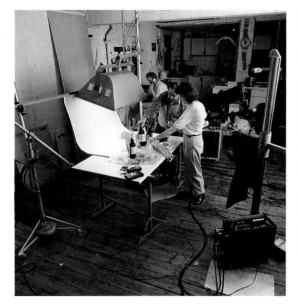

models, for instance, will carry their make-up and some personal props. You should have a check-list to prevent expensive items being left at remote locations. Allow plenty of time to travel to and from the set and allow plenty of time to clear up when you leave.

COST

When spin-offs are taken into account and the overall cost spread across two or more briefs, organizing a location shoot can seem feasible. But build into your figures the cost of a studio re-shoot, in case the weather ruins everything. It is possible to take out relevant insurance, so check whether the photographer is covered when you commission him.

Other ways of cutting down the cost of exotic locations include contacting airlines and hotels to ask for free travel and accommodation in return for a credit, although this approach is suitable only for editorial or catalogue work.

You may be able to brief a photographer to take speculative test shots, possibly in return for a small retainer giving you first refusal on the pictures. This can avoid both travel picture library fees and the expense of the photographer's travel.

TIMING

Before a shoot takes place, location-finding may be necessary, costed at a daily fee. Wherever possible, make sure that you get a written report and snaps or Polaroids of the location in return for this fee. In general, a location shoot will be more time-consuming than a studio-based shoot, while the photographer and his team create the perfect conditions.

So that you make the best use of your time, for both location and studio work, ask the photographer how long he expects the set-up time to be so that you do not arrive too early. You may be able to spend a few hours in your office while you wait for some test shots to be sent for approval before going to the final shoot.

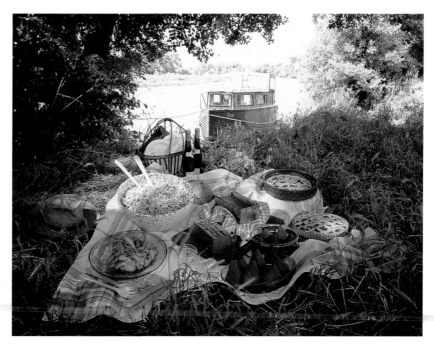

Setting up the shoot

WHEN YOU APPROACH YOUR CHOSEN PHOTO-GRAPHER you should explain exactly what you require, and have a written description and a visual interpretation of what you want the end result to be. This meeting should preferably be face-to-face, but a combination of telephone and post would do. At this stage, you should ask for any suggestions the photographer may have, provisionally book a date that suits your copy deadline and ask for a written estimate of the final cost.

FINDING THE TEAM

One of the most expensive elements of commissioned photography is not the photographer, but the team needed to provide the back-up facilities to ensure that everything proceeds smoothly.

On a fashion or beauty shoot in a studio, for example, you will usually have to employ two photographic assistants, a make-up artist, a hair stylist, a fashion stylist, a PA to prepare food (or pay for catering to be brought in), possibly a background artist or interiors stylist to provide a realistic setting and, of course, the models. The hire of special lighting equipment is also chargeable to you. If the same shoot takes place on location, you will incur additional expenses for transport, travelling time and, possibly, for an overnight-stay and all meals. You may have to employ a location-finder, and a location fee might be payable for the rights to take the pictures. With all these people relying on you, insurance against adverse weather conditions is essential.

The team needed for a food shoot will include a home economist, a prop-house to find the cutlery, glassware, linen and so on, and a stylist to find the accessories – all for a daily fee.

As we have seen, a car shoot may need a special studio and a team of four or five assistants. If you want to get a new angle on the vehicle from above, specialist lifting equipment will be needed.

FINALIZING THE BUDGET

When asking for an estimate, you may find it useful to ask for the components to be itemized separately (see Budget checklist, facing page).

You might send a typed sheet with these headings on it to all the photographers you ask to quote so that you can be sure of getting exactly comparable estimates. If some elements are fixed, the photographer needs to know this. If you intend to negotiate for copyright of the image, you should ask the photographer how this affects the fee at this stage in the negotiations.

You should make it clear whether you want the photographer to recommend and book all back-up staff, locations and so on – this has the advantage of ensuring there is a team used to working together. When this happens, the photographer may charge you for the whole package and so cut your own administration costs. You should, however, still ask to see the invoices from all participants for your own accounting and VAT purposes.

If the photographer does not work this way, you may be responsible for booking all the extras. Start to build up a file of studios, make-up artists and so forth. Ask your colleagues for recommendations and what sort of charges you can expect.

When the estimates come in, add 10 per cent as a

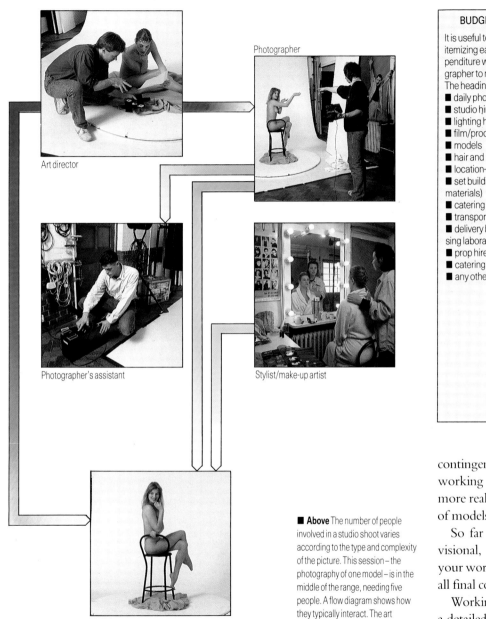

Photographer

Art director

Photographer's assistant

Stylist/make-up artist

Model

BUDGET CHECKLIST

It is useful to draw up a list itemizing each category of expenditure when asking a photographer to make an estimate. The headings could include
■ daily photographic fee
■ studio hire
■ lighting hire
■ film/processing costs
■ models
■ hair and make-up
■ location-finders and fees
■ set building (including all materials)
■ catering
■ transport
■ delivery bikes (to the processing laboratory and so forth)
■ prop hire
■ catering
■ any other services (specify).

contingency budget – this final figure is your working budget. At this stage you may need to be more realistic and perhaps cut down on the number of models or shoot in a less exotic location.

So far all your approaches will have been provisional, but if the quotes you receive are within your working budget, you should now plan to book all final contributors to the shoot.

Working back from your copy deadline, draw up a detailed timetable of the dates by which you need to have each contributor's work completed. If time permits, call a brief pre-production meeting with the photographer and all back-up staff to make sure that they all have the same objectives in mind, and to foster a sense of team spirit.

However, a successful photographic shoot can be marred by a subsequent wrangle over contract. There may even be threats of legal action, and it is essential for all art directors to be aware of the consequences of entering into contractual arrangements either by themselves or through a secretary acting on their behalf. Such arrangements would be equally binding on their employers.

A contract, which need not be in writing, for oral contracts carry equal weight, is a legally binding agreement by which a person or company enters into an agreement to provide goods or services to another person(s) or company in return for valuable consideration, which is most likely to be money, or money's worth.

All contracts must include a number of basic elements including offer and acceptance, certainty of the terms, possibility of performance and the intention to create legal relations.

An art director who is setting up a shoot may wish

■ Some UK photographers use confirmation of commission forms, which state their standard practices in legal terms on the reverse side and if studio hire and one experienced assistant are included in the daily rate.

to use a studio, props and the services of hair stylists, make-up artists or a variety of other services provided by people whose business it is to provide such services. So a request from an art director to anyone providing such services, to say nothing of the commissioning of the actual photographer, would inevitably be held to be an intention to create a legal relation.

Even an oral agreement on the telephone can be said to be sufficient to create a contract and there, sometimes, lies the basis for future problems.

When entering into any agreement it is essential that both sides are aware of their rights and responsibilities. An oral contract to hire a studio for, say, £250 a day is binding in law. But what does the fee include? Does it include the use of props, lighting or other necessary equipment or will a surcharge be made? And if it is necessary to stay late, who pays any overtime?

Both sides to the agreement must be clear about such relatively mundane matters as these or trouble can arise, and that is why it is always better to get confirmation of *all* relevant details in writing.

Art directors who use photographs from picture libraries should read and understand the terms and conditions – some of which could be onerous – before entering into any contractual agreement, and an art director or photographer who wishes to make money by placing photographs with a picture library must be absolutely certain whether that library is demanding exclusive rights and for how long. Again, the moral is: read the small print, for only in exceptional circumstances will a court overturn an agreement entered into voluntarily.

At the end of the shoot it is important that you as art director, the photographer and the model all sign a model release form. This form confirms the use to which the photographs will be put, the hours the model has worked and at what rate, and clarifies the administration between the model agency and yourself. You should note, however, that if the photogra-

ILLUSTRATION/PHOTO CONTRACT

Name_____

Address_____

Phone_____

JOB DESCRIPTION:_____

DUE DATE:_____

RIGHTS: I hereby grant F&W Publications, Inc. first North American serial rights to this material for one-time use. The rights herein granted include the right to reuse the material for promotional purposes as F&W may determine. I understand the rights to the material automatically return to me after the material's publication, and that if F&W wants to reprint this material in any form for resale, it will pay me 25% of the original purchase price for reprint rights. I understand the artwork will remain my property, and will be returned after publication.
ALTERATIONS: I understand I shall have the first option to make any changes to the material required by F&W. No additional compensation shall be paid unless such changes are due to error on the part of F&W.
CANCELLATION: Should F&W cancel the assignment after it has been substantially completed, for any reason, or cancels the completed assignment due to the work being unsatisfactory, F&W will pay a cancellation fee of 50% of the purchase price.
PURCHASE PRICE: $_____

To constitute this a binding agreement, please sign and date this form in the space below and return the white copy to F&W for its files.

Signature_____

Social Security#_____

Date_____

Authorized Signature_____

Title_____

■ Right A model release form is another essential document protecting the client's agencies and photographer's continued rights to use the pictures. It is essentially protection against unreasonableness on the part of the model and against the model's possible objection to the way in which the photograph might be used or retouched.

■ Left Commissioned editorial photography usually involves less stringent contractual demands, partly because rates and overall expenditure are less than in commercial and advertising work, and partly because there are no branded products to protect from market competition. This publisher's standard form acknowledges the photographer's rights in the pictures, which it is assumed may be re-used.

AD.AGENCY/PHOTOG	1
MODEL AGENT	2
MODEL	3

Standard release form for signature by models issued by the Association of Fashion, Advertising and Editorial Photographers, Association of Model Agents and the Institute of Practitioners in Advertising

NAME OF PHOTOGRAPHER

NAME OF *ADVERTISING AGENCY/CLIENT

PRODUCT, SERVICE OR PURPOSE

NEGATIVE SERIES NO. ORDER NO. DATE

In consideration of the sum of £...... and any other sums which may become due to me under the above Associations' current * Terms, conditions and standards for the engagement of professional models in still photography", and conditionally upon due payment of the aforesaid sums and the undertaking of the *Advertising Agency/Client/Photographer given below, I permit the *Advertising Agency/Client/Photographer and its licensees or assignees to use the photograph(s) referred to above and/or drawings therefrom and any other reproductions or adaptations thereof either complete or in part, alone or in conjunction with any wording and/or drawings solely and exclusively for:

* **EDITORIAL**
* **EXPERIMENTAL**
* **PR**
* **PRESS ADVERTISING**
* **POSTER ADVERTISING** (4 sheet upwards)
* **DISPLAY MATERIAL AND POSTERS** (under 4 sheet)
* **PACKAGING**

in relation to the above product, service, or purpose

* **IN THE UNITED KINGDOM**
* **IN EUROPE**
* **WORLDWIDE**

*MODELS MUST DELETE IF NOT APPLICABLE

I understand that such copyright material shall be deemed to represent an imaginary person unless agreed, in writing, by my agent or myself.
I understand that I do not own the copyright of the photograph(s).

* I am over 18 years of age.

NAME (in capitals)

SIGNATURE OF MODEL

ADDRESS/AGENT

DATE WITNESS

Models who are under 18 years of age must produce evidence of consent by their parent or guardian

In accepting the above release the *Advertising Agency/Client/Photographer undertakes that

the copyright material shall only be used in accordance with the terms of the release.

*MODELS MUST DELETE IF NOT APPLICABLE PRINTED IN 1984

phy is so successful that it is used beyond the purposes you specify on the model release form, the agency is entitled to negotiate an additional fee for the model's day's work. This is particularly applicable if you do not buy the copyright from the photographer and he syndicates the work overseas at a later date – the agency can still approach you as the original commissioner.

Model release forms are on sale from the Association of Photographers in London and the APA in New York. Model agencies sometimes provide models with a simplified docket, which you should sign after a shoot. This is not an adequate document, however.

COPYRIGHT

Your most important contractual arrangement, however, will be with the photographer, and this is not just a question of the contract for the shoot itself (for which the same standards will apply to the photographer as to anyone else who provides services for the shoot) but of the copyright in the photograph. In the past there was no difficulty about this: the person who commissioned the photograph (in this case, the art director or the company on whose behalf he was acting) would have been the copyright holder unless the contrary was agreed with the photographer, and the copyright in the photograph would last for 50 years from the end of the year it was first published.

Now this has changed: with the Copyright, Designs and Patent Act 1988, due to come into force in mid-1989. A photograph comes under the heading of artistic work and is defined as a recording of light or other radiation on any medium on which an image is produced, and which is not part of a film. As far as an employed photographer is concerned, the employer is the first owner of any copyright in the work, subject to any agreement to the contrary. With a freelance photographer, however, the position has been reversed by the new legislation. The photographer now owns the copyright in a commissioned photograph and that copyright lasts for 50 years *after* his death.

Nevertheless, a wise art director will deal with the question of copyright when negotiating the contract with the photographer. Because copyright is a property right, the owner, in this instance the photographer, can assign or sell all or part of the copyright and it is imperative if this is to be the case, that there is absolute certainty.

For how long is the copyright being assigned? Is the copyright to be assigned for just advertising purposes? Does the person who pays for the copyright have the right to use the photograph(s) worldwide or just in the UK?

These are just some of the important but often overlooked questions that need to be asked *before* a shoot takes place. It is vitally important to remember too that the new copyright legislation gives a freelance photographer a number of other rights, one of which gives him, unless the contrary is decided, the right to be identified with the photograph whenever it is published commercially, exhibited in public, broadcast or exhibited in a cable programme. Another moral right conferred by the Act is that the photographer's work may not be doctored without permission nor may someone else's work be attributed to him. These rights are enforcable at law.

Finally, it is worth remembering that, under the new legislation, if a person commissions a photograph, even though the copyright belongs to the photographer, the commissioning person has what the Act calls a right to privacy. This means that the photograph cannot be used or exhibited in public without the consent of those depicted in the photograph, so in obtaining a release for use of such a picture, state what use it will be put to.

Should there be the slightest hint of any legal problem, the art director should seek professional advice at the earliest possible moment.

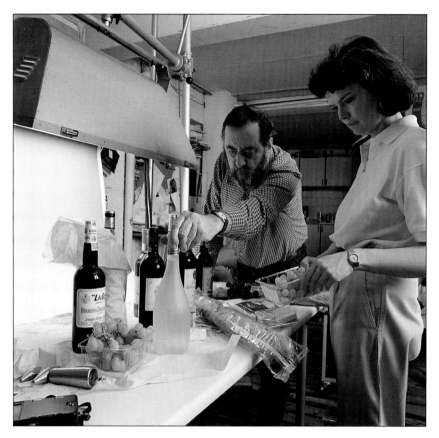

■ **Above** During a studio shoot, the art director is closely involved in all the studio operations and the activities of support staff, such as the home economist shown here at right.

incurred. When you and the photographer are happy with the composition, the photographer may invite you to view further adjustments through the camera.

A lot of time on all shoots is spent waiting around for subtle adjustments to be made to lighting, to hair and make-up or in food preparation. Do not unnerve the photographer by shadowing his every move. It is far better to let him take several rolls of test film in the final format and then break for lunch while they are sent for developing.

Do not be too rigid in your approach. Let the photographer shoot a few images (for example, from a different angle) that give an added twist to your idea.

At the end of each day's shooting some transparencies may already have been processed for viewing – if the work is a rush job, this will certainly be the case – and are viewed on a light box and may be cropped using cropping right angles, which the photographer will have in his studio. The films are scrutinized for sharpness by using a magnifying lens on a lightbox.

When you are working with black and white film, the negatives are processed and a contact strip or proof made, consisting of all the negatives printed as positives but the same size as the negatives. This allows you to view all the shots and decide by marking the strip with a chinagraph pencil or a ball-point pen, which ones to enlarge.

The quality of black and white print can be changed dramatically by process exposure times (see page 132). Many photographers will do their own printing or use a process house that they can visit and oversee the work for themselves.

When the photography is complete, and the pictures have been selected and cropped, a meeting is arranged with the client. If everything is satisfactory, your next task is to return to your studio to prepare the artwork and layouts for reproduction.

YOUR ROLE DURING THE SHOOT

On the day of the shoot, your role is to ensure that the photographer works within the budget and to the brief that you have set. The objective is to see that the format of the finished picture suits your layout and intended use. The photographer will, therefore, set up a test shot or series of shots on Polaroid for you to view. Crop these mentally to fit your page design so that you can judge how the composition is working. Remember that the Polaroid does not provide a accurate guide to the finished quality in terms of colour or sharpness.

It is up to the photographer to direct the people in front of the camera, your help may be required with back-up staff, and whenever an extra expense is

SECTION TWO

PHOTOGRAPHIC

PROJECTS

STILL LIFE PHOTOGRAPHY

STILL LIFE PHOTOGRAPHY is the basis of many photographers' workload. It can take the form of pack shots for advertising, electrical appliances for catalogues or designs for book covers, or can be creative location photography.

As art director you can obtain a precise result more easily with still life photography than, for example, on a location shot or using live models, because you can concentrate on detail and not have problems of movement or weather changes.

However, art directing still life photography has its own pitfalls. You will sometimes have to work on several objects, for example, Christmas hampers for a store catalogue. You must decide which items should be dominant, because, of necessity, not all can be given equal emphasis. A drawing will be helpful as a start, but re-arrangement may have to take place *in situ* to achieve the most satisfying balance, and you may sometimes end up designing through the lens.

You may have avoided movement by shooting in still life but surface reflection can be a cause of headaches. Reflection from glass and metal objects can enhance the final picture, but the lighting will need to be arranged in order to control and direct these to form shape and pattern.

The mood that is to be created will dictate the props you select. A warm bucolic one can be achieved with country pine, grain, seeds and flowers; a pure, cool style to promote classic china

■ **Right** The tone of this advertisement for Harrods' sale (one of a series) is restrained and the style of the photography had to reflect this. The key part of the brief to the photographer was to make an elegant, compact arrangement of the shot's two ingredients – pans and wrapping tape – and light them in a simple, cool fashion.

MIDDLE TAR As defined by H.M. Government

DANGER: Government Health WARNING: CIGARETTES CAN SERIOUSLY DAMAGE YOUR HEALTH

■ **Above** Visual puns are the hallmark of this cigarette poster campaign. This image emphasizes the twisted shapes. The photographer achieved this by using a focusing spotlight at a raking angle to a white surface.

■ **Below** Still-life photography was chosen for this Grace Jones record cover rather than a portrait in order to create a more striking image. First a cast was made of the singer's face and from this a mask. In order to make a small cut-out version in the top right corner, the photographer had to take a second shot against a white background, to define the edge of the mask and leather.

GRACE JONES RE-MIX RE-MASK
Slave to the Rhythm, My Jamaican Guy, La Vie En Rose, Private Life

■ **Below** Although less glamorous than the still-life shots, photographing watches for a catalogue demands equal care. The small size of reproduction makes it important to light them clearly, without shadows and without reflections from the glass faces (which may have to be removed for the photography).

and glass needs a minimal background; sinister items, such as bullets or broken glass, are required for a detective novel. But whatever props you use, the viewpoint of the photograph is all-important. For example, if you are shooting a display of china for a magazine, you may decide to look down on the objects, with the camera directly above them and little background detail. The lighting will need to be arranged so that the shadows cast give depth and perspective to the china. If you are working on a catalogue, on the other hand, it may be more important to show a clear profile against a plain background.

Before the shoot, however, you must know exactly how much background you want to photograph to include in the final image so that you have room for type above and around the object. This is particularly important if you are working on advertising or book jackets, for example. You should have a rough trace of the finished piece that you can use during the shoot to check that your layout will fit the proportions of the photograph.

Catalogues

A DAY'S SHOOTING of still life photography for a catalogue will require considerable organization and careful planning. You should set a target for the number of objects to be photographed each day, but be sensible, and relate the target closely to the subject matter. For example, if you are working with small electrical goods, lamps, plugs and so on, the background and lighting can be similar for each shot, which will be much more straightforward than working on a store catalogue, for which the subjects will vary widely and will require different sets, lighting and approach for each department. Smaller items will be photographed in the studio, but furniture and perhaps linens and other bulky items will be shot on location when the shop is shut or at a warehouse. You may decide that it is logical,

in the long run, for all photography to be ! work, which has the advantage that props available from each department and the fina logue may have a more integrated look.

All this must be planned well in advance of th shoot and before you engage the photographer. Clear thinking and pre-planning now will save wasted time and money during the photography. If the catalogue displays items from many different sources, try to group the items into those to be shot on location and those to be shot in the studio, although this may not always be possible. If the items are valuable – for example jewellery or paintings – a security guard or representative of the company may have to attend, and this may further restrict availability of the object. You must investigate these factors carefully before you start the practical work to avoid delays during photographic sessions, which can last for some weeks for a large and complicated catalogue.

The style of the photography will depend, of course, on the market for the catalogue. You should study the market closely and liaise with the client before commencing the work. A specialist manufacturing brochure needs to be smooth and constant in its approach to reflect the style and sophistication of the product. The background and lighting should be simple, possibly even severe, and it should define the shape and style of the object. Household goods, on the other hand, call for well-lit, user-friendly backgrounds, with plenty of appropriate props and, in some cases, people to demonstrate the use of the appliance. Other items, such as medical instruments, must be shown with dignity and clarity.

■ **Below** For the bulk of non-fashion consumer products the purpose of a catalogue is to deliver essential information succinctly; clarity is more important than imagination. Space is at a premium in a typical layout like the one below, and large numbers of photographs often have to be used, each very small.

■ This page In two spreads from the same catalogue, both art director and photographer have had to meet the challenge of producing and using many images of similar household products together. One solution has been to run one large, attractively lit and styled picture adjacent to a block of small identical pictures (**right**). These last fit together more comfortably on the page by having the same backgrounds – the camera remains on its tripod and only the items are changed. In the spread (**above right**), parts of the two larger shots are allowed to break out of the frame to give more life to the layout.

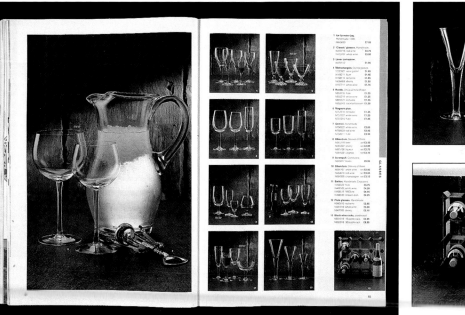

Book jackets and record sleeves

AS ART DIRECTOR you may also be the designer of a book jacket or record cover; alternatively, you may be involved only in the photographic direction. If you have designed the jacket or cover, you may adopt a freer, more creative way of producing the image, working through the lens in the studio in a more or less *ad-hoc* style, with the design in your mind and little more than a simple sketch on paper. This method can produce very original and exciting images if you have a reasonably clear idea of what you want to achieve in the final photographic design. This approach, however, should be attempted only with some degree of caution, for it can be a recipe for much fruitless use of studio time, and if the photographer thinks time is being misused, he or she may lose confidence in you.

The best results might be achieved with a combination of the two approaches. Have a clearly drawn instruction to give to the photographer, but keep an open-minded attitude with regard to re-arranging the composition in the studio. If you are not the designer, the finished rough must be closely followed on the photographic shoot.

Still life photography has produced some very memorable and atmospheric dust jackets for detective stories in the last few years. The paperback covers for books by Len Deighton and Reginald Hill, for example, have been excellent representatives of the genre. The preparation of the final artwork generally involves re-touching the image and some amount of airbrushing to achieve the transition from photography to graphic design.

The images used on record covers do not always convey the atmosphere of the music as clearly as the items used on, say, covers for crime fiction; in fact a surrealistic ambiguity would appear more the intention at times.

Photomontage and all the technical effects available to the dark room and computers can be deployed, and the studio work may represent only a small part of the creation of the sleeve. The style of art direction most usually adopted for this type of design is for a highly finished visual to be presented to the photographer for technical interpretation. Pure still life photography of the kind used for book jackets is less often used in this field of design activity.

■ **Below** In a layout that is more than usually dependent on precise arrangement, the cover for this book was conceived as an edge to edge display of objects. To ensure exact placement the photographer was provided with a scaled rough of the title and type area so that the composition could be built up around it.

TYPE AREA.

IMAGE AREA.

Right To give a documentary atmosphere to this historical picture book cover, contemporary photographs were used as objects rather than just images. In order to underline this treatment, a background of planks was used and coloured gels were hung in strips in front of the single focusing spotlight.

Right This record cover is also partly a photograph of a photograph. The lettering cut in stone was first photographed alone with a single naked flash (**right**). The resulting 4 × 5in transparency was then placed on a glass sheet, underneath a small fish tank with goldfish. This was lit from below, with appropriate shading where the fish were lit from the side. This elaborate procedure was needed for reasons of scale: the lettering had to be large for precision and would otherwise have needed a much larger tank and bigger fish.

Above In this colourful record cover, the job of the photography is no more than to complete a design that is successful mainly in its conception. There was no need for any special photographic or lighting skills, and to have put time and money into a creative photo session would have been a waste.

Magazines and brochures

THE MOST IMPORTANT CONSIDERATION in magazine work is the house style or image of the publication. All magazines fall into a market category – they are often described as up-market or mass-market – and it would be a disaster if the style of art direction and photography were conceived for the wrong market and not applied correctly to the readership. If you are commissioned on a freelance basis to produce a feature, time spent in studying several issues of a magazine will bring a swift reward. The subject matter, props and even the lighting will be particular to the magazine, as will the age and spending power of its readers. Many product brochures have borrowed their style from up-market magazines and photography for these is likely to have more in common with magazines than catalogues.

Each type of magazine or brochure will be in the market for good photography, but the style and, therefore the art direction, will be very different. Once you are aware of the special requirements of the publication, good results can be created within the constraints of the magazine format and style, and some of the best still life photography has been commissioned for magazine publishing. Although some publications have their own staff photographers the output is such that they all use freelance photographers as well.

Magazines often create room sets as a backdrop if the feature warrants such expenditure, and they may prefer natural lighting to create a friendly atmosphere. Polaroids may be used to set up the group

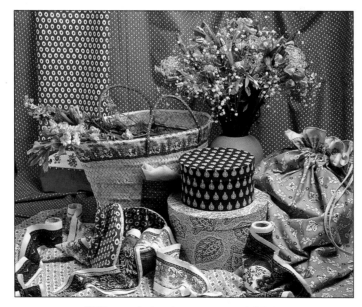

■ **This page** An alternative to showing individual photographs of similar objects is to combine them into one set – and give this a theme. Here, arranging the floral fabrics in a mass that bleeds off at all sides gives homogeneity, while complementing them with two bunches of flowers establishes a summery atmosphere.

■ **Below** The back cover of a catalogue that does not have to carry advertising can be put to work as an extension of the front. This fabrics catalogue has a wrap-around cover, photographed so that the front cover occupies the right-hand half of the 4 × 5in transparency (**right**).

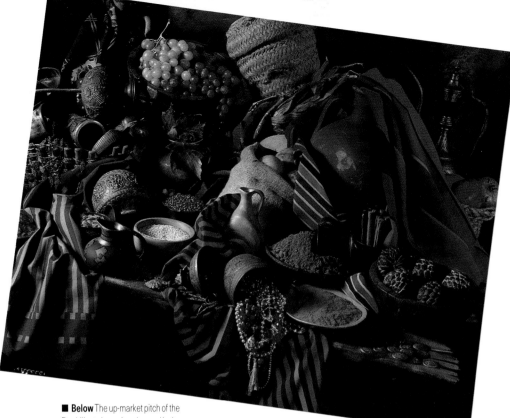

■ **Below** The up-market pitch of the Dunhill catalogue is enhanced in the layout by playing off full bleed straightforward fashion photography against elegant still-life arrangements.

before the final photography takes place, because it is unlikely that any drawn image is available for the composition. The size of the photograph is decided on a layout, but the content is put together on the day with the help of the home economist, who also provides the items to be photographed.

Working on trade or specialist publications – radio or camera magazines, for example – has much in common with working on technical catalogues. The objects must be clear in concept and in production; the background must be minimal and the lighting simple; and the definition of shape and general technical detail sharp. Flower and plant publications use a similar approach for studio work, but much is done as location photography and it is likely to be more atmospheric in concept.

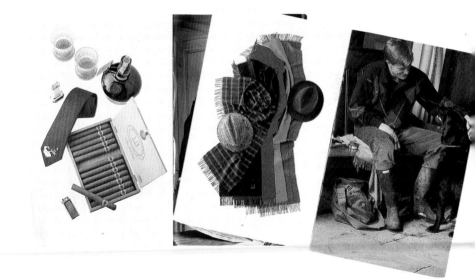

Advertising

A STYLIST WILL PROVIDE the props for advertising photography, and the art director must give clear, even written, instruction as to what will be needed. The budget will, generally, be more than generous, and great care is taken to find exactly what is wanted for the precise picture to be executed.

Still life photography is, in many ways, the bread and butter work of an advertising agency, whether it is simple black and white press advertisements or large, glossy posters for display on 48-sheet sites. Since it was banned on television, cigarette advertising has been the main subject for still life work by the large advertising agencies.

The use of still life by agencies falls roughly into two categories. First are straightforward representations, known as "pack shots", of such items as perfume bottles, photocopiers or television and video sets. Second are shots that employ photomontage and various exotic styles and techniques to create an arresting image more painterly in execution than recognizable as a work based on photography. An art director, working on one of this second type may have to use artists as well as model makers. The rough visual produced to show the client and to brief the photographer has to be a highly developed and finished visual to give the right impression of the completed advertisement.

Remember, however, that once the client has approved the composition shown in the visual, any changes that are made by re-arranging the composition must not involve the basic concept,

■ **Below** In a conventional treatment for a small advertiser who wants maximum recognition of the product, this studio still-life arrangement uses simple and essentially frontal lighting (for minimum shadows) and a straightforward tiered arrangement that packs the most items into a vertical picture.

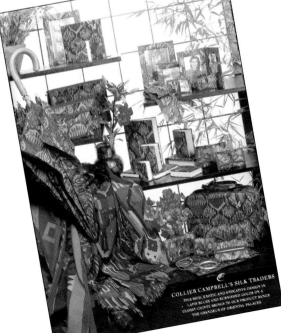

■ **Below** Understatement is used knowingly as an advertising technique for London's most famous store. The photograph hints at the forthcoming sale, without being explicit.

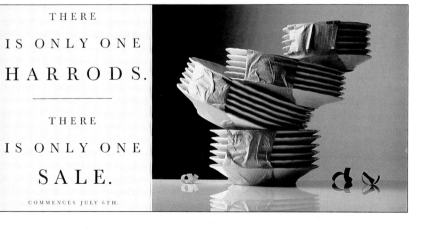

THERE IS ONLY ONE HARRODS. THERE IS ONLY ONE SALE.

COMMENCES JULY 6TH.

otherwise the publisher may refuse to accept the altered design and more photography will required, this time paid for by the art director.

When the photography is complete it may be decided to print a full-size version on paper so that a dummy can be made up, with lettering, photoset or by an artist, to send out to retailers on a pre-publication sales drive. This will have been decided before the shoot, and the photographer will provide the necessary prints after the session.

■ **This page** One of the most famous campaigns of recent years for Benson & Hedges cigarettes relies heavily on style and cleverness in the photography for the simple reason that advertising restrictions on tobacco make it virtually impossible to say or imply anything positive about the product. The oblique style and a patch of gold cover carry much of the brand recognition on their own.

Still life book jacket

THE ART DIRECTOR was sent the manuscript by the publisher and selected elements of the text that were graphic and symbolic of the story, in order to brief a designer to produce some rough visuals. One or two of the ideas that seemed to be developing in a way that fitted the story were worked to more finished design. The art director asked a visualizer to complete a finished visual that would fully convey the style and appearance of the finished photographic design. This could have been done in airbrush or pencil, or with markers. The finished design was sent to the publisher for approval. Often a design is not right for a book because it does not relate to the public's ideas about the subject matter. A book may also need another jacket for sale abroad.

When the client had approved the visual, the art director looked for a photographer, who was a specialist in this type of work. The photographer and art director discussed the style and content of the book, and the photographer contributed his own ideas for achieving a satisfactory composition and layout for the jacket.

The rough design was sent to the studio in order that the objects could be obtained prior to the photographic session. If a firearm had been included in the still life it would have been advisable to contact the local police station or to select one of the realistic replicas that are now widely available.

The lighting was important to give the right mood to the design and was carefully considered and discussed. Various backgrounds were considered; the one that was chosen was of a colour that produced the correct mood and atmosphere.

■ **This page** After reading the manuscript for this thriller about the Nazi occupation of Poland, the art director produced rough visuals (**above**) which contain ideas that were subsequently developed into a more finished design for the book jacket.

Right The art director (**right**), photographer (**centre**) and stylist (**left**), examine the props that the stylist has collected using the finished rough on the facing page as a guide.

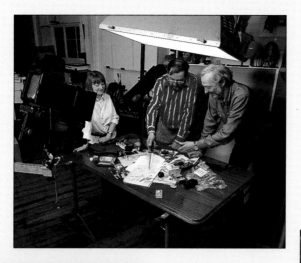

Below The art director begins the composition by trying out different props against each other. At this stage he is concerned primarily with balancing size, colour and texture.

Left The art director examines prints made of the documents and photographs from the period that are the key objects to appear in the still-life. From a number of choices he selected just three.

Left As the documents and photographs are copy prints, and so in pristine condition, an early step is to "distress" them by crumpling, staining and singeing to make them look sufficiently old.

■ Left to below This sequence of four photographs shows the development of the cover image, from the early shots containing objects later rejected (such as the miniature camera) to the final refinements. As ideas in still-life composition frequently emerge at the time of shooting, it is usually essential for the art director to be on hand to take decisions. In the third shot, for instance, the wooden desk top was replaced with a painted canvas background, but after discussion it was reinstated because of its more natural appearance.

POLAROIDS FOR TESTING

Like the majority of editorial still-life photographs, this shot is taken on a 4 × 5in view camera, for which a variety of Polaroid instant print films are made. Polaroids are an accepted, integral part of studio photography, not so much to confirm exposure calculations (experienced studio photographers are sufficiently familiar with their lights to be consistently accurate), but to allow the composition to be studied in print form. As the viewing screen on these cameras gives only a dim, inverted image, this is a considerable help for the art director.

■ **Below** In the finished picture, the final refinement is in the lighting position. Taking the light back over the set, partially facing the camera, gave more prominence to the spectacles by casting their shadow, as well as giving more interesting texture to the crumpled paper and knife blade.

FOOD AND WINE PHOTOGRAPHY

FOOD IS, WITHOUT DOUBT, one of the most difficult subjects to art direct and photograph. The problems are many and various, the main one being timing and co-ordination; cooked food will reach perfection at a certain point and will remain in this condition for minutes or even seconds. A soufflé or pudding can collapse before the shutter opens. Even the best prepared dishes can look disappointing, dull and lifeless on film or even look unreal.

The colour of food, especially vegetables, and drink is a critical factor in the final picture. Most of the people who look at magazines or books about food will have some knowledge of cookery and will make a judgement on the quality, often based on the colour alone.

Some years ago, in order to overcome these problems, much substitution was employed in culinary photography. Ingredients were used that looked, rather than were, right. Mashed potatoes replaced ice cream, cauliflowers were painted with white poster paint to restore their yellowing tips, glue was added to gloss a dying dish, colour added to tired vegetables and many other tricks were thought up to give the poor innocent public what they thought they wanted. Then the law stepped in, and deception of this description was banned. Experts in food photography have now developed a highly skilled approach, which may still involve touches to improve looks but will not affect the quality of the product. Well-known food manufacturers and packagers will not tolerate their goods being treated in a deceptive way, and ways and means have been developed to overcome many of these problems.

Food photography requires a specialist team, which usually includes a home economist to prepare the food and a stylist to provide props and assist with the arrangement of the set.

Thorough preliminary discussions with members of the team should help to reduce last-minute problems with coordination and timing. You also need to make sure that the chosen studio or location has adequate facilities for the preparation of the food.

■ **Left** Although the ultimate purpose of most published food photography is to illustrate recipes or to sell specific food products, this should not preclude inventiveness. With the help of an illustrator commissioned to paint the background, the photographer here has blended real life with *trompe l'œil*. The plate itself is half sunk into a fibreglass base.

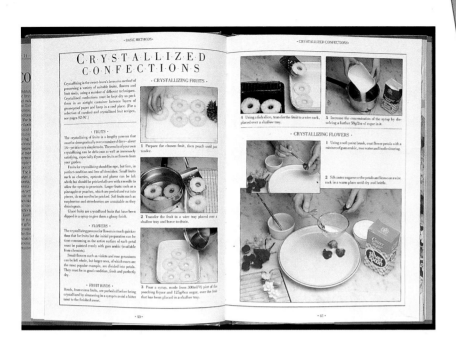

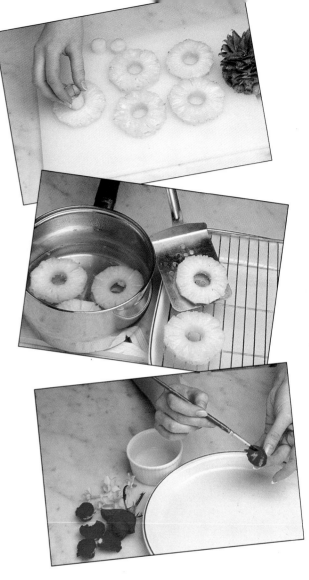

As art director, you must consider the time and the budget available for the work. You will not be expected to know the various ways food can be made to look attractive, but you must know how to convey what you want the pictures to look like in the printed image.

Different types of food require different ways of being displayed. Fresh fish can look very wholesome if it is displayed as multiples with very little background shown. The impression that they are freshly caught conveys just the right feel to the photograph. You can show them on stone, marble or straw matting, or experiment with ways of grouping them, heads and tails pointing in different directions, or, sardine-like, displayed in rows with military precision. Raw ingredients tend to look well when photographed flat on a surface so that the patterns they produce can be exploited to good effect. Beans, peas and leeks all lend themselves to this type of display, but any uncooked food that has a defined shape will adapt to this type of composition. Fruit such as apples, pears and oranges often

■ **Above and right** In recipe photography there is often a need to show the successive steps in cooking. For consistency it is usually best if the same lighting and camera angle is used for the complete series, as in this spread illustrating the preparation of crystallized fruits and flowers. The hands must be attractive and unblemished and should normally be shown cropped at the wrist.

looks best when stacked or piled high in an attractive bowl. Alternatively, the cut-open fruit with some cheese and a glass of wine or juice makes an attractive still life image.

Cooked food requires a different strategy. A display of chops or steak would not benefit from this type of arrangement. All cooked food must appear in the process of cooking or as a dish about to be consumed, and most photographs of the cooking process are close-ups.

Food photography in the studio

THE ARRANGEMENT OF THE STUDIO is critical in cookery photography. A kitchen is essential, and it needs to be a fairly comprehensive one, with, if possible, facilities to cook several dishes at once. Microwave ovens are useful additions. It is important to maintain a smooth flow between the cooking and the photographic area, and you should visit the studio before the shoot to make sure of all these points. During the shoot itself there may be six or more people milling around the area, so space is an important consideration in the pre-shoot survey. If you are directing a shot in which the food is to be shown being cooked or prepared – as in a cookery book step-by-step sequence – you will need to make sure that the kitchen area is suitable for the shot or, alternatively, arrange for a kitchen set to be built.

Successful art directors develop an ability to anticipate and try to prevent problems arising during photography. You may be able to make some tactful suggestions about small rearrangements to a studio before the shoot so that your job can be photographed in a more practical way and avoid later headaches. If you are not satisfied that the studio is going to be suitable for the task you have in mind, it is far safer to look elsewhere. You should also discuss very fully any props or settings you may want to use on the project. The setting can be a major consideration in food pictures, and showing

PUDDING
AS EASY AS PIE.

complete meals, tablecloths and place settings, for example, calls for careful selection and arrangement.

Magazine clients are often prepared to build a background or room set, and you should provide a comprehensive drawing of what you have in mind. It may be that an existing one can easily be adapted to your use, but you should allow time in your schedule for one to be built from scratch.

Most food is, or should be, decorative and colourful, and a dark, simple background often displays food to perfection. Most photography of actual cooking arrangements is shot from the side or at a slight angle, so backgrounds are more or less vertical projections. Sometimes a more romantic

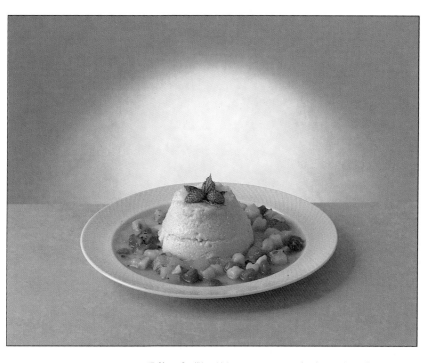

■ **Above** Soufflés, which are a considerable test of cooking skill, also challenge the photographer. Once upturned on the plate, they can collapse quite quickly; there is no room for delay. As soufflé is an up-

market dessert, the art director wanted a setting to match – simple, clean, but warm in atmosphere. No props were used, and the photographer created an echo of the plate's curve by aiming a light from under the table at the wall behind.

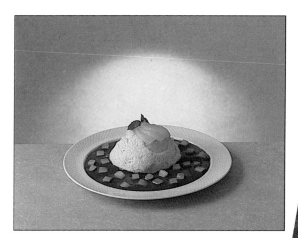

■ **Above** In the layout, the art director chose to crop tightly, losing part of the halo effect of the light on the wall in return for being able to fit two photographs neatly on the right

hand page. The antique marbled paper background for the spread was chosen to enhance the sophisticated nature of the dishes.

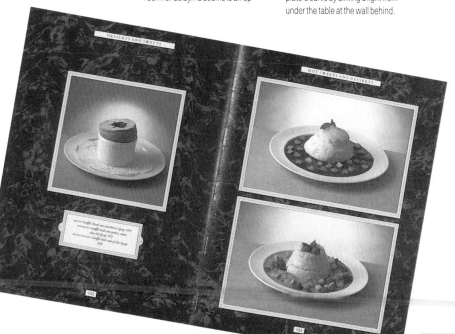

■ **This page** The organization and planning of a food advertisement can be complex. For this range of packaged soups two kinds of photography were commissioned: four fully styled food shots, each in a studio set evoking a particular country, and four pack shots of the product against specially commissioned map artwork, each taken with a rostrum camera.

style is adopted, and a window showing a garden or landscape may be incorporated into the design, either as a set or as a superimposed photograph. A job for an hotel or restaurant might involve a similar picture of a table with interior background, but this is more likely to be taken on location.

The subject of the food to be photographed will influence the atmosphere of the picture to be created. Exotic, unusual fruits and vegetables will often dictate the colours and backgrounds of a composition and, in this type of photography, which is often associated with a travel article, the props and backgrounds are almost as evocative as the food depicted. You should have a general plan of operation, but do not be afraid to let the photographer be creative with the lighting.

A practical book or part work that has stage-by-stage shots describing the preparation of a dish requires a pragmatic style of photography. All the ingredients need to be seen clearly, and every item that is going to be used must be assembled according to a fully worked out plan – remember that the object is to enable the reader to become a fully fledged, foolproof cook. The photography must trace the steps that will be taken by the reader, so that there is no confusion about how the ingredients are used. Both the director and photographer must take great care to achieve the most convincing shot from an instructional point of view.

Light will play a vital part in the discussion. Not

only is it important to show clearly the operation that is taking place, but it is worth remembering that the position of the lighting will help visually to describe the objects and their texture, which is important in the identification of food – for example, the texture of bread can be crucial in photographing wholemeal loaves. The use of texture is especially helpful in black and white photography, but the light may have to be harsh to obtain the effect, and this could mar the picture.

■ **Left** Balancing pack shots against food shots requires care: the former create brand recognition for when the reader is in a supermarket, but it is the judiciously lit and styled photography that makes the product look appetizing. As finally used, the food photographs have been given the more prominent display.

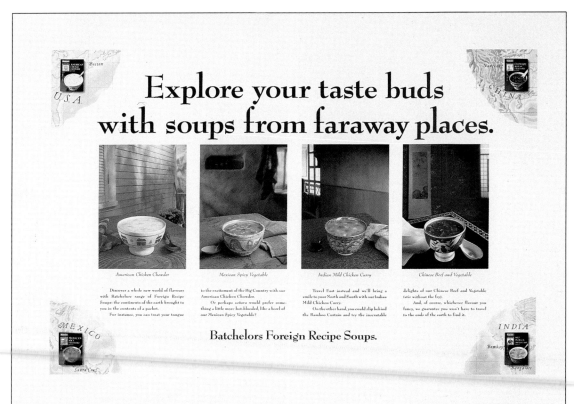

Explore your taste buds
with soups from faraway places.

American Chicken Chowder *Mexican Spicy Vegetable* *Indian Mild Chicken Curry* *Chinese Beef and Vegetable*

Discover a whole new world of flavours with Batchelors range of Foreign Recipe Soups: the continents of the earth brought to you in the contents of a packet.

For instance, you can treat your tongue

to the excitement of the Big Country with our American Chicken Chowder.

Or perhaps *señora* would prefer something a little more hot-blooded, like a bowl of our Mexican Spicy Vegetable?

Travel East instead and we'll bring a smile to your North and South with our Indian Mild Chicken Curry.

On the other hand, you could slip behind the Bamboo Curtain and try the inscrutable

delights of our Chinese Beef and Vegetable (stir without the fry).

And, of course, whichever flavour you fancy, we guarantee you won't have to travel to the ends of the earth to find it.

Batchelors Foreign Recipe Soups.

■ **Right** In the original photography for the coffee advertising campaign featured on this page, a number of different compositions on the same theme were tried. In the upper shot, closest in style to the experimental image at the bottom of the page, the very low camera angle made it necessary for the photographer to use the view camera tilt to the full, to preserve front-to-back sharpness. Even so, the jar could not be held completely in focus. Therefore a separate, similarly lit photograph was stripped into the final image.

■ **Left** This minimalist treatment from a photographer's portfolio provided the inspiration for the style of photography for this campaign. What caught the art director's imagination was the generous and unconventional use of space, and the geometric division created by the folds in the tablecloth.

A series of food photography for, say, a glossy magazine will require an entirely different approach to atmosphere and lighting. The photographs will not need to concentrate on the instructional aspects that are necessary in part works. Shadows can be used to emphasize the sensual qualities of the culinary delights on offer. The photography must try to convey a sense of smell, even to make the viewer hungry and want to taste the mouth-watering cuisine that is available through the camera lens. The approach can be painterly in an attempt to create a mood that will show the food to the best advantage. Backgrounds can be deep in colour and mood lighting can generate shadows. There will be opportunities to experiment with special highlights, and lights can be placed around the image and reflectors set behind glasses to enrich the colour of liquid in the glass and introduce interesting reflections. With this style of subjective image making, you may want to design through the lens rather than by a precise visual rough.

Food photography for packaging tends to be a combination of the objective and subjective approaches to image making. The subject must be clearly shown on the pack or box, of course, and it must look attractive. At the same time, the image must be atmospheric, and while the shape, texture and colour of the subject must be clearly observed, they must not look at all clinical. The view will almost certainly be a close up, and the background minimal, or flat or continuous graded tone. If a plate is used to display the food, it will generally be simple

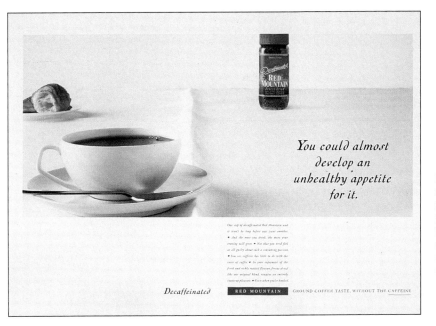

You could almost
develop an
unhealthy appetite
for it.

Decaffeinated **RED MOUNTAIN** GROUND COFFEE TASTE, WITHOUT THE CAFFEINE

■ **This page** As used in the campaign. The precision of placement and composition in the photographs has been taken further in the layout, both by tight cropping (cutting the curve of the lid at the top of the frame) and by the typography (the red bar echoes the jar in the picture). The overall effect is as conceived: clean, refined and up-market.

with perhaps a band of colour as an edging. The style is precise, and in fact, such rigid rules now control the composition, especially of frozen foods, that the style has become classic.

When the actual food is seen, the picture should appear to dissolve into a mass of highlights and mouth-watering gloss. A creative photographer can use every item in his visual vocabulary to exploit the subject as a very eatable still life. As art director, though, you must ensure that the formal arrangement and rather austere framework that the client wants is retained.

The labels for tinned food are not constrained by these formal guidelines, however, and a more adventurous approach can be adopted, perhaps with a landscape or set as a decorative background to indicate the country of origin. This may be combined with a drawn image to complete the illusion.

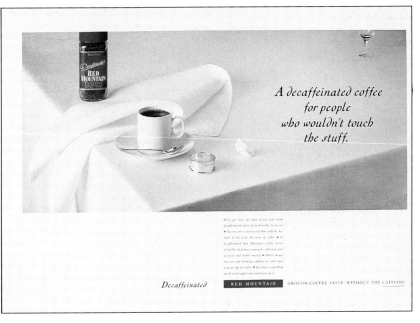

A decaffeinated coffee
for people
who wouldn't touch
the stuff.

Decaffeinated **RED MOUNTAIN** GROUND COFFEE TASTE, WITHOUT THE CAFFEINE

Food photography on location

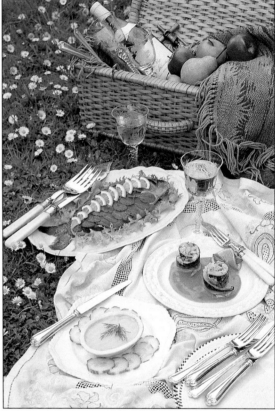

WHILE A STUDIO HAS THE GREAT ADVANTAGE of convenience in food photography, it may not be the most suitable situation if atmosphere is the important factor. The alternative – location photography – offers a set of surroundings that can both enhance the mood of the image and bring certain connotations to the dishes. For instance, a salmon dish photographed on the banks of an attractive river with the appropriate fishing props will instantly suggest freshness and something of the romance of

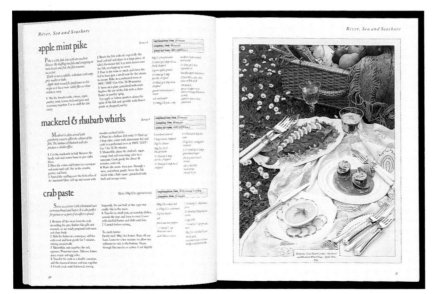

■ **This page** A picnic location helps to enhance the atmosphere in this English cookery book. The styling (hamper, silverware, glasses, etc.) sets the up-market tone. An overcast sky has the technical advantage of giving soft, even lighting that is good for photographing the silverware.

the countryside. Ethnic and regional foods may benefit even more from locations that set the scene, while dishes that are suitable for eating *al fresco* are also likely to benefit from such treatment. If you are proposing a shot of a summer picnic, for example, in most cases the precise location should be such that the foreground space is fully taken up with the food, while the key elements of the location – buildings or landscape – appear just above, in the distance. Depth of field, therefore, is an important consideration.

Set against these benefits, however, location photography has considerable problems of logistics. In many countries the unreliability of the weather is a major factor. If it rains, how do you keep the food

and the team dry? On the other hand, if an assignment takes you to a hot country where rain is almost unknown, your problem may be how to prevent the team getting sunstroke. With careful planning, you can work during the coolest periods of the day and make use of shade from buildings and trees, but keeping food cool might be more of a problem. Some countries reach such peaks of temperature that food can be cooked on flat stones, and your beautiful desserts will melt and all the salad will wilt before the shooting starts. Water, sprayed at regular intervals between shots, will help, and a refrigerator is a must, so, unless you can organize a portable generator, this may dictate your proximity to buildings.

If you are working for some days in a cold climate that is subject to rain and dramatic changes of temperature, some form of weather protection is essential to the smooth running of the project. Most location food photography involves a building of some sort – hotel, country house or well known restaurant – and an open shelter may be available in the grounds so that you can set up the cameras and equipment under cover, to photograph out into the landscape. Remember to have a waterproof cover to put over the food if it starts to rain. If existing cover is not available, you might have to use an open tent or marquee.

Salads and fresh vegetables often look their best displayed under trees on a bench or table, and you may know someone with a garden that could be used for this purpose. Lamps can be used to create the effect of sunshine if the weather is overcast.

■ **This page** For the same cookery book, this photograph is consistent in style with the one on the facing page. A greenhouse is used here to establish a summer location, and as a result the camera angle is lower. Although the greenhouse could have been brought into focus, it has been deliberately left soft so as not to compete for attention with the food. Importantly the dishes in the shot are similar in style to those in the recipes on the facing page.

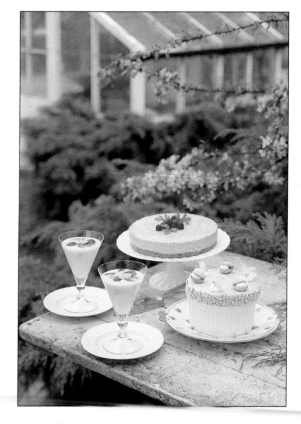

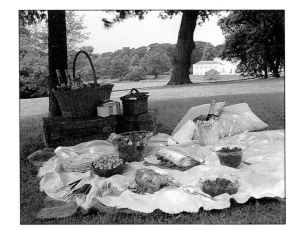

■ **This page** The styling for this photograph called for the suggestion of a country estate. The location chosen was an eighteenth century house in a London park and for which permission was necessary. Dappled shade provides attractive lighting that is not as harsh as direct sunlight. The pale pink tablecloth performs the double function of displaying the dishes clearly and providing fill-in reflection.

sure you have a reel of cable and plugs as part of your equipment. This is in addition to your normal lighting equipment, because it is likely that you will have to use lamps to provide a constant light. Passing clouds can change the effect on an outdoor food shot with unexpected and alarming rapidity.

Once again a visit to the location before the shoot is, if possible, a great help in finding the props, tables, benches and pottery needed to create the atmosphere and setting. If these are not available, they will have to be hired for the day. Antique shops in nearby towns will often help out with this type of hire, and a reasonable rate can generally be agreed. If you are using a home economist or stylist, they will take care of this, but you will have to specify very clearly what is wanted, perhaps even providing Polaroid shots as a guide.

Keeping the food hot is the next problem. Try to establish camp as near as possible to the kitchen. Use a dummy still life to take light readings while you set up the shot and have several versions of the food or dish prepared to take the place of the one that is cooling. Some form of heated container may be available on a long lead from the kitchen, so make

■ **Below and right** This photograph of cakes in an orchard was taken in full sunlight, to convey the feeling of high summer. Direct sunlight, however, was considered unattractive, particularly for the glazed toppings. As no shade was available with the right background, a white cloth canopy with two branches attached was erected. On the layout the two foreground tarts were cut out to add interest and depth to the spread.

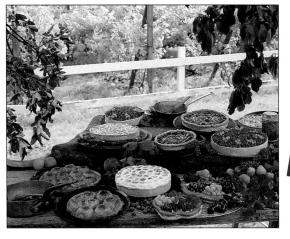

■ **Right** Also shot on location for the same cookery book and by the same photographer as the photograph on the facing page, these cakes and hampers were placed against a tree trunk. Because the natural shade from the tree allowed no interesting modulation of light, gold foil reflectors were used to enliven and warm the lighting effect. As the photograph was planned for a double-page spread, the two hampers on the left were stacked to make a natural vertical line that ran just to the left of the gutter.

Photographing drinks

PHOTOGRAPHING WINE AND OTHER DRINKS in bottles and glasses requires a special approach, because you are concerned with both the liquid and its container. Most bottles and glasses have reflective surfaces and so have particular lighting needs that may well be at odds with the light needed for the liquid. Drinks photography is, in fact, a specialization within the already specialized field of food photography. Lighting is of such importance that it is advisable, if you are hiring a photographer with whom you have not already worked, to see specific examples of drinks photographs in his or her portfolio.

Drinks vary in the quality of their transparency – white wine, for instance, is more transparent than red – and the greater the volume, the darker they will appear; it is virtually impossible to see through a heavy red wine in a bottle, for example. The most effective way of showing the liquidity and colour of transparent drinks, is to use some form of back-lighting.

Straightforward back-lighting can be achieved either by placing an area light directly behind the still life set or by having a white backdrop which is lit from the sides, top or bottom. Without any supplementary lighting, this will show the transparency and colour of the liquid and make a silhouette out of the container. The disadvantage is that the background is limited to a light colour, which may restrict your overall design. An alternative approach is to mask the beam of a lamp played onto a white background so that only a limited area behind the bottle or glass is bright, this area then shades to a darker tone above. Remember that, with back-lighting, a "horizon" will be formed by the back

■ **This page** For chapter openers in a book on spirits of the world, the problem was to give a general visual impression of each country. A massed still-life of all the brands would have been pointless, as succeeding pages would be detailing each of these. The design chosen was a close detail, with a drink in the foreground and an image associated with the country behind – cocktail shaker in the case of North America, a Martini label for Italy.

edge of whatever surface you place the drink on. This technique suits very simple, graphic layouts in which the container is not an important part of the image. Nevertheless, if the glass has a thin edge, this may virtually disappear from view under back-lighting. A normal solution to this is to place sheets of black card on either side, close to the glass and just out of frame; their reflections will help to define the edges more clearly.

Pure back-lighting can be dramatic, graphic and provide good contrast, and can be ideal if the colour of a transparent liquid is an important element. It is, however, a limited style, and there are likely to be many occasions on which the basic lighting needs to be more conventional – that is, more frontal. This is particularly so if the shape of a bottle is important. If the label must be clearly seen and if there are other props, the back-lighting for the liquid must be solved separately. For instance, the glass of a bottle of beer is likely to be fairly dark, usually brown or

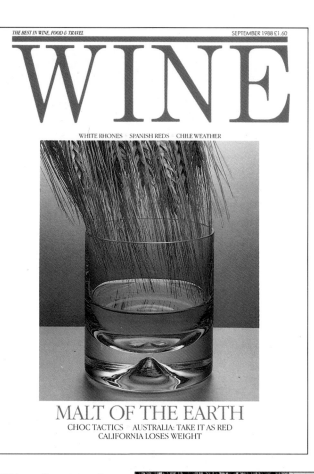

THE BEST IN WINE, FOOD & TRAVEL SEPTEMBER 1988 £1.60

WINE

WHITE RHONES · SPANISH REDS · CHILE WEATHER

MALT OF THE EARTH
CHOC TACTICS AUSTRALIA: TAKE IT AS RED
CALIFORNIA LOSES WEIGHT

NO HEATHER? NO HIGHLANDS? WHAT KIND OF SCOTCH IS THIS?

J&B

UNCOMMONLY GOOD SCOTCH

■ **This page** These photographs show two different approaches to the task of presenting whisky. They both deliberately set out to stand apart from the general run of images. Thinking of a new approach is a challenge as this spirit has been heavily advertised. **Above and right** The wine magazine's answer is visual support for a pun: as the cover line is all-important. The photograph has been executed in an extremely simple, unadorned manner. In the J&B advertisement (**left**), the text again supplies the theme: the rejection of whisky clichés, supported by a spartan set.

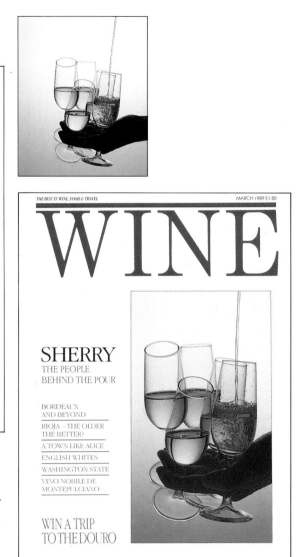

This page This cover illustration on the theme of dessert wines is styled as a classical, painterly still-life, with low-key lighting to contribute to the atmosphere. A fully worked-out set, in which the accompanying props do part of this work, is one of the most established treatments for food and drink.

green, which makes the liquid difficult to see. This may suggest a design in which the beer has already been poured, or partly poured, into a glass standing by the side. A clearer way of defining the shape of the bottle is to light from one or both sides, using an area light large enough (or close enough) for a continuous band or panel of light to be seen reflected in the bottle from top to bottom. The same method applies to all standing bottles. If the shoulder has a sharp angle, as in a claret bottle, for example, the light may need to be adjusted to avoid a break in the reflection. As a rule, reflections of a light source in glass look better when they are large, even and have a simple, regular shape, and diffusion with a large, translucent sheet of, say, Perspex or Plexiglas, is, therefore, standard practice. You might also con-

sider giving the reflection the appearance of a real window by asking the photographer to place vertical and horizontal strips of black tape on the translucent sheet to imitate window-pane dividers.

This basic lighting may be sufficient for a bottle of dark red wine, but for a more transparent liquid, the clarity and colour will be low. A standard solution is to use a small mirror or piece of foil positioned directly behind the bottle or glass so that it reflects

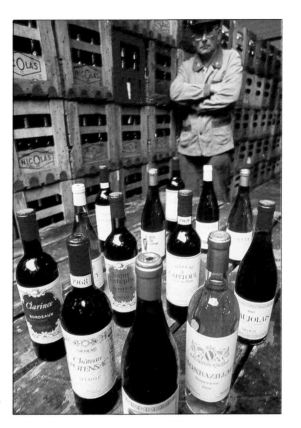

some of the main light. The effect will be to light the liquid. The shape of this small reflector and the distorting effect of the container and liquid will together determine the shape of this bright-lit area; ideally, the reflector should be adjusted or trimmed so that the entire volume is brightly lit. Be sure that the reflector itself is not visible.

Sometimes when photographing an old bottle, a vintage port, for example, it may be desirable to eliminate all reflections on the bottle and concentrate on showing a sparkle on the glass containing the ruby drink. The bottle can be covered in dust, as if just brought up from a cellar, by spraying glue on the bottle to ensure that the dust lies on the surface. Some cheese and bread will finish this off nicely.

Racks of bottles can form an interesting and unusual backing for wine photography, and this may be a location shot in a wine merchant's cellar. Grapes and vine leaves will help to give a good atmosphere to the pictures. Red and white wines require different lighting in the studio if they are to be seen to advantage. The red wine should remain more or less dark in tone and offer a rich mysterious quality. The lighting should be rather low and general in aspect, giving a hint of backlight. This is the best way to display the character of red wine, but it may need to be slightly lighter in use if the paler reds of southern France are the subject.

If there is a label, it will need to be visible, although it is often better not to show all of it as it

■ **Right** The dusty and encrusted appearance of a vintage port bottle is itself evocative. A roughened, neutral setting is in keeping with this, while side-lighting from a single area light (or window-light as it is also known) best shows the bottle's surface. Note that careful positioning of the light places its reflection along the entire height, with a small break that defines the shoulder.

obscures the wine itself. Showing half to three-quarters of the label is a satisfactory compromise, provided the first few letters of the name can be read.

An alternative approach is to concentrate on the texture of a drink. This usually means creating some improvement in the liquid, by pouring it to introduce movement or swirling it around in the glass. Provided that the lighting has been positioned to reflect in the surface of the liquid, a flowing texture and droplets can enliven the image considerably.

The appearance of having been freshly poured is expected and looked for by potential consumers of some drinks. The head on a glass of beer, for instance, is critical, and will often mean setting up the lighting with one filled glass, but shooting with a fresh glass at the moment of pouring. Make sure you have sufficient numbers of clean glasses and fresh bottles.

Ice presents its own special problem. It must look clear, transparent and well shaped, and to achieve this it may be necessary to prepare the ice carefully beforehand from distilled water or to buy it in large quantities from a known source. Another major problem, of course, is that it melts under studio light, which both softens the edges of the cubes and dilutes the liquid. For both these reasons, acrylic ice cubes are commonly used. Remember, however, that real ice floats, while acrylic cubes sink, and it is better to fill a glass with ice, positioning the cubes carefully to control the appearance and refraction.

Bubbles also contribute to an appearance of freshness in some drinks. They can be created by stirring just before shooting or by blowing gently into the liquid with a straw or thin tube. Excess bubbles may then have to be removed by pricking. An alternative is to use hand-blown tiny glass bubbles on the water line.

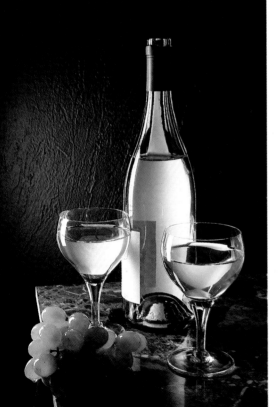

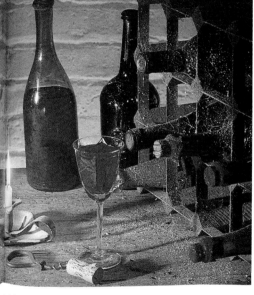

■ This page In both of these spreads from the same book on wine the layouts called for a cut-out panel for the text on one side of the page. This meant composing each shot so that the background was continuous, while keeping the wine bottles right of centre. Apart from measuring the composition on the ground glass screen of the 4 × 5in view camera, the backgrounds had to be simple and understandable behind the text panel. In spreads like these, the central gutter is another important consideration; depending on the binding, it can distort parts of the image that cross it.

■ **This page** The photographs on this page show how different lighting solutions can affect even a simple shot of wine bottles and glasses.

■ **1** A side strip light produced a vertical reflection that gave shape to this bottle of Burgundy. **2** Turning the bottle to show only half the label allowed the rich colour of the wine to be seen in the bottle. **3** Finally, a top light was added that gave colour to the wine in the glass. **4** This bottle of claret was intially lit simply with a side strip light and a top light to give a plain reflection. **5** An artificial window reflection was created by sticking tape strips to the Perspex light cover. A reflector on the left provided additional lighting interest. The top light was moved to the right and the strip light that provided the vertical reflection was moved forward to enhance the shape of the bottle. **6** In the final shot the window reflection in the glass provides contrast to the rich colour of the wine. **7** The soft reflections produced by lighting these bottles of German white wine through a diffuser screen gave a flat effect. **8** Hard reflections from side and top lighting defined the bottle shapes more effectively. **9** Placing the full glass next to the bottle reduced the reflection on the side of the bottle. The top light provided effective treatment of the wine in the glass. **10** This light red Provençal wine was lit from both sides to provide shape and crispness. **11** This frosted glass bottle of Frascati was softly lit from the side and rear. **12** A similar lighting solution as for the Provençal wine (10) was used here, except that as stronger top light was used to assist the lighting of the wine in the glass. Foil placed under the bottle strengthened the reflections here.

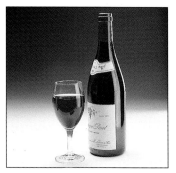

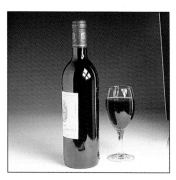
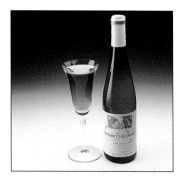

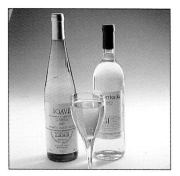

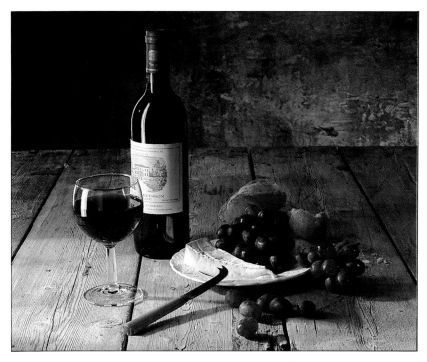

■ **Left and below left** These two similar shots of wine and cheese show how effective lighting combined with carefully selected, but simple props and backgrounds can produce an atmospheric treatment of this subject. **Left** The impression of light streaming through a rustic kitchen window was created by a screened fish frier light. An uncovered strip light gave a hard highlight on the bottle and glass and additional lighting under the table provided definition of the horizon. **Below left** The lighting from the top and rear gave dramatically contrasting highlights and shadows.

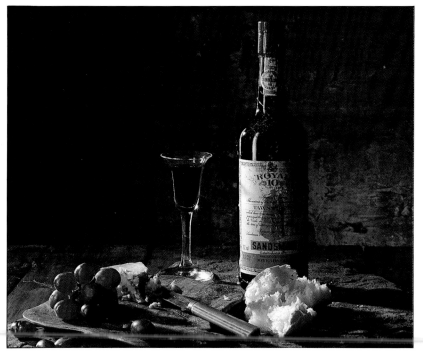

■ **Above** A clean, fresh effect was produced by a dominant side strip light. A balancing relief light to the front and left was also used. The dappled lighting of the background (produced by a spot with a patterned filter) picks up the browns of the sherry in the glass.

Problems with photographing food and drink

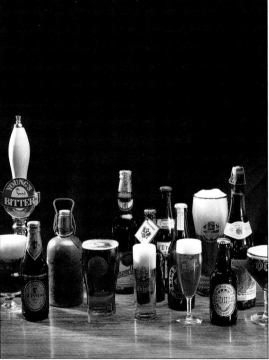

WHETHER THE SHOOT IS taking place in the studio or on location, food photography poses some unique problems. Most experienced photographers will have developed their own techniques for overcoming the effects that studio heat and light have on food. As you gain experience of directing shoots, you will pick up some short cuts and hints, but in general these tricks of the trade are the responsibility of the photographer. However, you should be aware of some of the difficulties that may arise during working in this very specialized area of photography and art direction.

Ice cream presents a major problem, of course. The only answer is to prepare a large quantity and have a team of helpers to take it in and out of the refrigerator so that, as one lot begins to melt, the freshly frozen version replaces it. Substitution is no longer an option because of changes in the law, but some help in the way of support is necessary during work on delicate desserts and puddings. This does not affect the quality of the food but is done to prevent sagging, unpleasant-looking dishes. A piece of wood can be placed out of sight to support a steamed pudding, or a cup can be carefully fitted to save a disaster. Wire is often used to keep vegetables together in an agreeable composition, while some vegetable stalks, which help to make the subject attractive, dry up under the lamps and have to be carefully removed, soaked and glued back in to place.

Quite often several dishes will be produced over a short period of time so that as one deteriorates the next arrives before the camera. Sometimes vegetables are uncooked and bubbles or movement added to create an impression of cooking. Steam can be a good indication that a dish is piping hot, and if the area around the food is kept at a fairly low temperature, it will appear quite naturally. Cigarette smoke is a substitute if all fails.

Fizzy drinks are often a problem because once poured they quickly go flat. Sometimes a chemical is added to restart the natural process, but the client may not be pleased if he finds out. A helper standing by to make another drink to be added to the first may manage to revive the flattening drink, and blowing air into the glass can prove a temporary

■ **Right** Timing is the critical factor in an action shot like this. For precision, it is normal to shoot tests on polaroid film first to gauge the best height from which to drop the acrylic ice cube. A large number of shots are usually needed to give sufficient choice for the final image.

■ **Below** Lighting for bowls of soup and similar dishes is conventionally from a position in which it is reflected in the surface. This shows the soup's texture, with highlights, but also reveals any congealing in the form of fatty globules. It is therefore essential to shoot when the soup is hot and fresh.

■ **Left** Timing of a different kind is essential in working with ice cream – it will begin to melt within several seconds under even the relatively weak modelling lamp of a studio flash unit. With the camera set up, and focused on a cone that is clamped in position, the scoops are photographed the instant they are in position.

solution to the problem. If you want to create an effect of condensation on a glass, grease the glass lightly and spray it with water. Spraying water helps to overcome many of the snags caused as the heat of lamps dries up the dishes, and a light coating of oil can revive fish and meat products.

Studio photography for a cookery book

PHOTOGRAPHING RECIPES FOR COOKBOOKS requires a great deal of planning and preparation before the shoot begins.

For this project, the first step was a meeting between the photographer, art director and the client to discuss the book thoroughly. All aspects, including the contents, style and the market at which the book was aimed, were considered and approved before the studio work commenced. The number of recipes or sections were decided; the number of photographs in each section were agreed; the proportion of pages with black and white photography and full-colour work established; and the layout of the photographs, in conjunction with the text, and the type of camera to be used – e.g., 10 × 8cm or 5 × 4cm (see Cameras and Lenses, p.124) – determined.

The art director, decided how to provide a visual treatment that complied with the client's wishes and produced visuals to show the client what the book might look like.

The next stage was a meeting between the photographer and the home economist who was to prepare and cook the food during the photography session, which, for this long and complex book, may take several weeks in the studio. They decided which and how many recipes were to be shot each day and in what order, and prepared lists of the ingredients to be supplied by the clients.

All practical aspects were now agreed and finalized to the satisfaction of all concerned and the studio photography was ready. The team arrived early for the day's shooting. The assistant made a

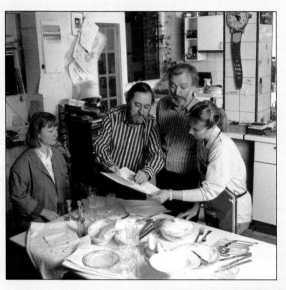

■ **Left** The preparation of a still-life photograph that will take the best part of a day to complete, begins with a meeting at the studio between the art director, photographer, stylists, and home economist. At this stage they discuss the choice of tableware.

■ **Right** The responsibility of the home economist (or stylist) includes the preparation of the dishes to a standard that is both appetizing and "correct". As with the props in the photograph above, the ingredients need to be chosen with care.

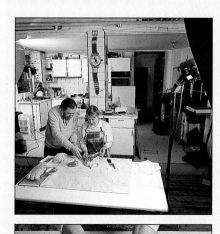

Right Part of the photographic brief is to shoot a series of step-by-step pictures that demonstrate how the final effect is achieved. This means setting up a second, less elaborate set, in the studio. The art director discusses with the home economist at what point in the preparation she should pause for the camera.

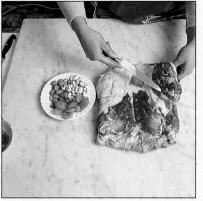

Above As the step-by-step photographs are likely to be used side by side in a sequence, they are shot all at the same distance and camera angle. A marble slab has been chosen as being appropriate to a kitchen and visually clean. The home economist's own hands are used, and these are positioned sufficiently far forward in each shot so that the photographs can be cropped at the wrists.

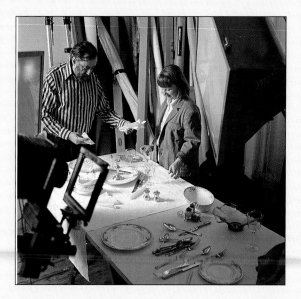

Right The art director and stylist discuss the props and prepare the main set as they wait for the food to cook.

check on the equipment and made sure that sufficient photographic film, both black and white and rolls of colour, was on hand in the studio. During the shoot the team worked from a storyboard or flat-plan with visuals of each shot as this was more convenient than a dummy. The photographer set up a dummy run, using objects to obtain light readings, while the food was being prepared for the first composition. Care was taken to avoid delays during the passage of the food from the kitchen to the prepared set.

A target for a day's photography was set. Although it is often not possible to stick to this entirely, it is as well to have a scheme as a guide. Problems in shoots of this kind arise to set back the daily schedule, but as the shoot progresses an average becomes established. The art director kept a watchful eye on all the team's activities making sure that at no time did anyone obstruct any part of the operation, because any delays in the photography would result in the client's fees being wasted.

When managing a long shoot, at the end of each day, if you think that any part of the operation could be improved to run more smoothly, it is up to you to have a word with the photographer, who acts as head of the practical team, and make a constructive suggestion about the changes you would like to be implemented the next day. This can be done in an informal way, as you are looking at the results of the day's photography. If any shots are unsatisfactory, you must decide if they should be re-shot or could be used with careful cropping. If the quality is technically below standard, a re-shoot must be included in the next day's schedule.

If you are working on more than one assignment during a week, you should visit the studio each morning and carefully review the plan for the day's shooting, trying to anticipate any problems that may arise, both technical or from a design point of view. After a few days working on one project, the

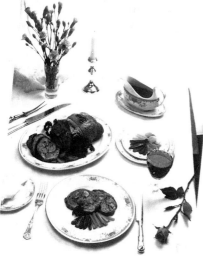

routine will generally become fairly well established. At the end of each day, you must return to the studio to make sure that everything has progressed according to plan, look at the contact prints for black and white photography or view the colour transparencies on the light box.

This method of part-time attendance is possible only if the pattern of photography is fairly consistent and each day's routine similar. The team should know where to contact you if snags arise during the shoot.

With all the photography finished and the cropping and selection finalized, the client was shown the transparencies and prints at a meeting with the photographer, art director and the book designer. Since everything was satisfactory and no reshooting was called for, the pictures were passed to the repro house to begin the reproduction of the art work.

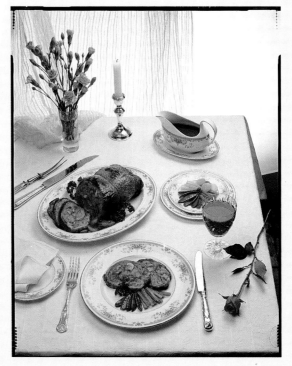

■ **Left** The final photograph, shot on 4 × 5in transparency film. A large, diffused mains flash unit was positioned in front of the camera and slightly above to give an even reflection off the silverware and the glazed skin of the duck.

Boned Duck Stuffed with Apricots, Leeks and Nuts

INGREDIENTS *(serves 8)*
3lb duck
Salt and white pepper
1 tbsp mixed chopped fresh
thyme and marjoram
5 small leeks
Lemon Juice
6 juniper berries
4oz unblanched almonds
4oz cashews
1 cup of dried apricots
1 cup quark or fromage blanc

1. To BONE THE DUCK *(see step-by-step illustrations on p.198).*

2. Open out the duck, skin side down. Trim *(see I below)* and season with salt, pepper and some of the thyme and marjoram.

3. Clean the leeks thoroughly *(see p.192)*, removing coarse leaves and most of the green part. Coarsely chop 3 leeks and the nuts and apricots.

4. Mix the chopped leeks, nuts and apricots *(see II below)* and spread over the inside of the duck. Season well with salt, pepper, lemon juice and herbs. Roll up the duck and wrap in cheesecloth *(see p.199)*.

5. Coarsely chop the remaining leeks. Put them in a large saucepan and barely cover with water. Add the juniper berries, remaining herbs, salt and pepper.

6. Place the duck on top of the chopped leeks and herbs. Cover tightly and braise gently for 1 hour. The duck is cooked when it feels firm and solid.

8. Remove the duck to a warm serving dish. Discard the juniper berries from the stock and blend the leeks and herbs with enough of the liquid to give a creamy sauce. Strain into a clean saucepan, whisk in the fromage blanc or quark, and season to taste. Do not boil lest it curdle.

9. Unwrap the duck and cut across into slices. Garnish with watercress. Hand the sauce separately.

I TRIMMING DUCK
With a sharp knife and your fingers carefully lift and cut away as much fat, membrane and gristle as possible.

II PREPARING STUFFING
It is important to mix the stuffing thoroughly.

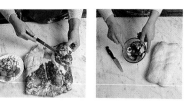

I *II*

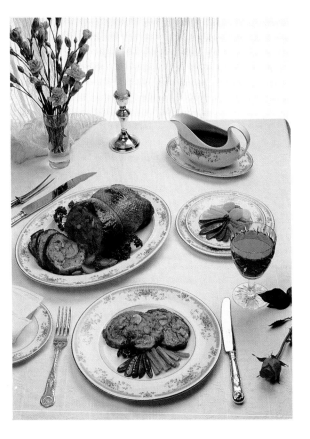

■ **Above** The finished spread from the cookery book shows how the practical step-by-step photographs and the sumptuous final shot of the meal work together to create an attractive and informative layout.

BUILDINGS
AND MACHINERY

THIS TYPE OF PHOTOGRAPHY covers a wide range of industrial subjects, including cars, machinery, aircraft, architecture and other large-scale subjects when the overall shape and composition are paramount to the concept and atmosphere.

Most industrial photography is, of necessity, location photography, although plant or other machinery, generally of a small scale, is sometimes shot in a studio. Most photographers who specialize in this type of work prefer to show the tractors in the fields or farmyards, the cars on the move or, if at rest, in an outdoor setting. For a brochure new cars

■ **Right** One of the tasks of an industrial photographer is to produce images that are graphically interesting. Often this is a matter of finding a particular viewpoint and choosing an appropriate lens – as in this shipyard photograph. A symmetrical view with a wide-angle lens is part of the standard repertoire.

are often photographed in the showroom or factory, but even then, many of the shots are taken in a suitable exterior environment. Architecture, of course, has to be location work unless you are photographing models of a projected building.

Working machinery benefits from human contact. It may be no more than hands showing some part of the operation or a long shot with people moving about or placed at strategic positions on the shopfloor. Close ups of cranes and earthmovers should include drivers or operators to help create a feeling of energy and movement, but long shots, showing their abstract sculptural aspect on a building site or on a dockside location, can provide interesting images. Bridges are usually photogenic with their graceful spans and curves.

As usual, when faced with this type of work or assignment, you must assess the purpose of the photographic message. Is the purpose of the assignment to show the restoration of an historic building or is it an agent's leaflet for marketing executive housing? Different attitudes and approaches will be required for each subject. The first needs to generate an emotive feeling or attitude towards the venerable structure, to persuade the viewer of its importance and the place that the building occupies both culturally and historically in society and to stress the necessity of its restoration. The housing development puts the emphasis on good, solid-looking buildings that will be comfortable and pleasant to live in and make into a home. Achieving the right atmosphere will depend on the clever use of lighting, the viewpoint, colour and background.

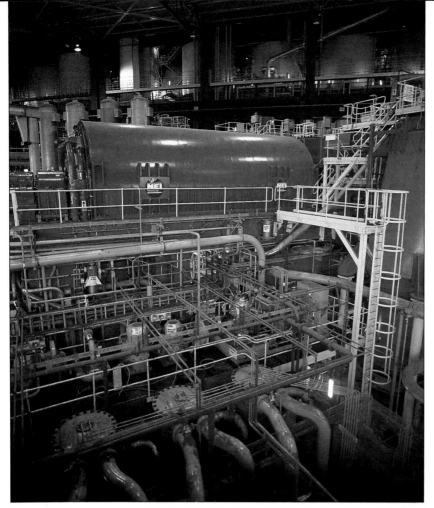

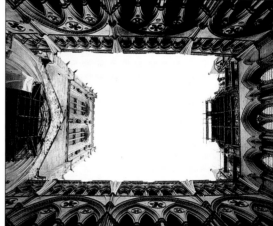

■ **Left** Industrial plant interiors often work very well in photographs when there is a coherent mass of machinery. Wide-angle lenses are usually necessary for a comprehensive view, but the camera position has to be chosen with care. Here, the blueness is due to existing mercury vapour lamps, left uncorrected for interest.

■ **Below** The formal design of religious architecture tends to restrict viewpoints. In this photograph, however, a shot taken with a wide-angle lens, looking directly up from the middle of a cloister, gives an unusual, and so eye-catching, alternative.

■ **Right** As in the photograph on the facing page, symmetry gives this stock photograph a clean, refreshing view of a multi-arched bridge in Beijing.

Architecture

WHEN PHOTOGRAPHING BUILDINGS, try to spot any details that might embellish the printed spreads and form an interesting foil to large-scale photography. Perspective will be your biggest problem, but it can be used to create interest and to project the size of the architecture. Technical attachments can be used to combat this problem, but if you decide that they will not help your design, work from distant shots and use a telephoto lens. Cropping and general editing solve compositional problems at the layout stage. Details of some stonework lit from the side to

■ **Right** Buildings and monuments that are already well known offer considerable latitude in treatment. Even under extremes of lighting or composition – as in this twilight view of Stonehenge – the subject remains recognizable. In fact, because such subjects have been excessively photographed, there is usually a need to find a different treatment, by means of viewpoint, lens focal length or lighting.

project the rough texture of the surface, look very good in black and white. Others, such as a golden-hued stone, will benefit from sensitive colour photography. Still life is plentiful as a subject in all church building – metal hinges, keys, small windows, plaques and gargoyles will be such tempting items for the camera that the selective process will be quite a difficult one.

If you are photographing an historic building, make yourself familiar with its style and characteristics. How does it relate to other buildings in the vicinity? If it is a church, how was it built to serve the community? Is it a parish church or a grand cathedral in a city townscape? If you have time, read about it for any background knowledge you gain will prove useful in making a judgement about the building's outstanding features and, perhaps, the less satisfying views of the structure.

When directing the shooting of an imposing church, cathedral or abbey, an honest reportage style to the photography will be the best solution. The majestic façades and perfect proportions of the nave and transepts will impart their own grandeur and dignity to the prints and transparencies without the addition of complicated viewpoints.

When photographing a small village church, the landscape and setting will be the paramount consideration. Often, large trees will frame a shot, and old gravestones serve a similar purpose. Try to include landscape that extends beyond the churchyard, a story-telling device that not only explains the setting and environment but expresses the rural nature of the subject.

Modern architecture is very different, and re-

quires a different approach and treatment. Perspective often helps to describe the building, while skyscapes, with the texture of cloud formation, dramatize and frame the picture. The outside surface of an office block is probably glass clad and reflective, a technique used by architects in recent years to prevent tall buildings looking dull and monotonous. This gives an enterprising photographer plenty of opportunity to exploit the sculptural quality reflected from nearby buildings. Balconies and other repeated details can combine to provide exciting abstract images photographically.

Often a traditional building, monument or fountain remains at low level beside a modern monolith, a feature that gives contrast and adds point to layouts. The pattern of wrought-iron railings, casting snake-like shadows against a dark brick or stucco wall, enrich black and white prints.

■ **Above** Glass-fronted office buildings give a ready opportunity for photographs that use reflections. For this shot the photographer waited for evening sunlight to provide colour interest. In the alternative shots (**right**), the photographer deliberately left space at the top for the magazine title. In the event the art director made more interesting use of the chosen frame.

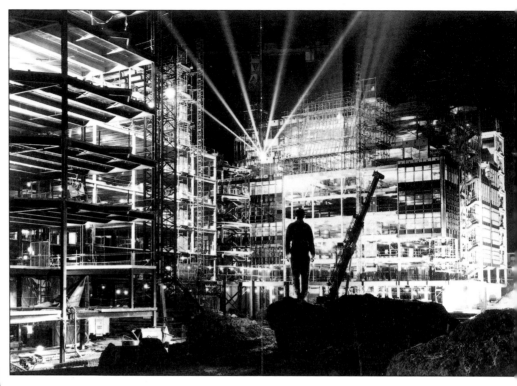

■ **This page** Publicity material for developments is often needed well before they are completed. Intrinsically, construction sites are unpromising material for photography and the art director's solution for this major development site was to commission highly stylized photography. In each image, figures are included – deliberately posed and, in the two daylight pictures, starkly lit by flash units from left and right. This technique gives a consistent visual style to the publication and adds excitement to an otherwise uninteresting subject.

Small, modern, domestic architecture may provide a large proportion of commissions for brochures for selling, both from the builders and estate agents. Such photography calls for a much more intimate style. The building site may resemble a battlefield, and the house material will be unweathered and a mass of different angles. The task will be to make the site attractive to a buyer, making it look desirable and good value to purchase. If some mature trees have been left in place they will prove invaluable as a frame for the picture. When there are none, the problem is how to find an attractive viewpoint. One solution may be to use part of a wall as an upright to one side. The pattern formed by a porch could be a helpful shape to enliven the composition. A soft focus might help relieve the harsh lines formed by the shadows cast from brand new buildings. Try to humanize the picture – figures and parked cars will improve the atmosphere – and cloud patterns may help to soften the composition.

■ **This page** Large-scale housing developments have a tendency to look similar – a problem that can be tackled by varying facing materials and details wherever possible. In this developer's brochure, sameness had been overcome by using a distinctive architectural detail – a brick arch – as the main picture on the spread. Visually this supports the main point in the text , that the developers are sensitive to the overall appearance of their projects. Smaller pictures suggest that the development blends in.

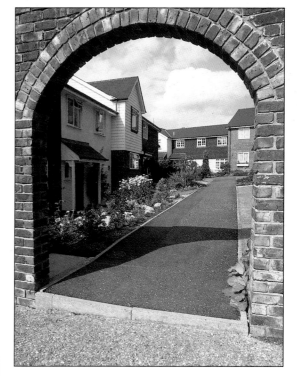

Interiors

LIGHTING IS THE MAJOR CONSIDERATION in the photography of interiors, and natural and artificial light is used to create a mood and show the subject to advantage. Public buildings, swimming pools, town halls and large hotels usually have well-lit reception areas, but concert halls and restaurants are extremely tricky to handle with success. A rock concert will almost certainly use special coloured spots to create the atmosphere and effects, and you will have to go along with this to some extent and accept the specialized colour that is the result of this concentrated display. Off-stage photography may offer the best viewpoint or a perspective shot from front of the house looking up.

Restaurants often have a low level of lighting to encourage the soothing atmosphere that is conducive to good eating. If a day-time picture is wanted, showing an empty dining room with a waiter or two and a culinary still life, natural lighting will suffice. If a soft-lit evening shot is wanted, try to use the pools of light on the tables, with the shadows as pattern and framing.

Museums also adopt low lighting levels, but here it is to protect the exhibits on display. Generally, agreement can be reached to spotlight an exhibit for a short period, and the result, contrasted against a sombre background, can prove very dramatic.

Domestic settings are less of a problem. Most homes are reasonably well lit and can quickly be improved by lighting existing lamps out of camera view, removing curtains and opening doors. If the weather is poor, extra lighting outside the windows pointing into the room will create artificial sunshine. In general, existing interior lighting is too contrasty for photography, and fill lighting is often important.

Studios, workshops and industrial sites are well lit for the workforce to use, but glare may creep into the exposures and this must be carefully avoided by masks or temporary screening to prevent unwanted light spots in the lens. In general, use existing lighting as much as possible because this will describe the activity and use you wish to portray in the illustrations.

■ **Below** The purpose of this magazine spread is to show the work of the designer of this New York restaurant. The photographer was asked to emphasize the modernity of the interior by a clean, graphic composition. The viewpoint intentionally stresses the distinctive curved steel rails. As lighting is integral to the restaurant design, the photographer worked with the available lights.

■ **Left** In this photograph, the interior is secondary to the fabrics, which are the subject of the picture. The interior is used to provide a context only. More than half of the picture area is deliberately taken up with the fabrics and the need to hang and display these prominently determined that it should be a studio shot. To convey the impression of a real bedroom, a false wall (with *trompe l'œil* painting) and window were built. Behind the window, a painted backdrop simulates an exterior view. From above and behind this backdrop a single, powerful spot reproduces the effect of sunlight.

Country style
. . . to a tea!

Whether you have a home in the country or simply aspire to country style, you can create the perfect setting with Chilton traditionally styled pine furniture.

The table and chairs

The storage

The china

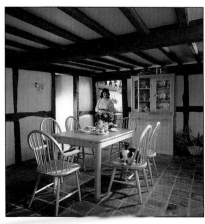

■ **Left and above** In contrast to the fabrics image, real interiors were used for this catalogue. Additional lighting from a spot out of frame at the right gives the effect of sunlight. As the china is on a different scale from the furniture, it is also shown in cut-out which adds liveliness to the finished page.

Large machinery

COMBINE HARVESTERS, EARTHMOVERS AND BULL-DOZERS are always painted in bright tones, usually red, green or yellow. This is for safety, so that they can be seen when approaching and so that they can be located at the start of the day on site, but this colourful paintwork gives plenty of scope for an attractive composition. Such machinery is seen on site, operating if possible. A red tractor provides an exciting image displayed against soft grey stone walls in a muddy farmyard. Harvesters cutting corn against a bright August sky require minimal dexterity to produce a delightful and evocative illustration, in long shot or at a suitable distance from the front of the powerful machine. All photography of this kind should emphasize the power and energy of the machinery. Earthmovers pushing rubble into ordered mounds and forklift trucks raising large stacks of crates in a warehouse are what the prospective buyer wants to see in the brochures and trade magazines.

Location and environmental photography is essential in this type of photography, and it is often shot in foul weather to show the versatility, strength and durability of the machine. Most of these vehicles are multi-purpose, and you should cover as many areas of activity as possible in one session. Lorries and trucks require similar treatment, but they are best seen from the front at a three-quarters angle, with powerful perspective treatment. Remember that the vehicles should be clean.

■ **Below** Location photography is usually the only solution for this type of photography but depends heavily on good light. In the truck detail below a low sun and clear air contribute greatly to the clean, bright effect. A long telephoto lens has been used to compress perspective so that the rectangular lines of the truck fit graphically into the 35mm frame.

■ **Right** Location photography of a different kind has been used as an imaginative solution to the problem of photographing the locomotives, shown right and on the facing page, to illustrate real-life working situations without the dullness and grime. The art director chose to photograph them at night. Providing lighting gave control over the design and atmosphere, but at heavy cost: 24 mains flash units, five generators, transport and a crew of eight.

Right Some large car studios will accept machinery of this size: the size of the entrance is usually the restricting factor. Lighting is often easier than for cars as most machinery does not have curved, shiny bodywork. Here there are relatively few planes to contend with and each has been individually lit, for the most part frontally.

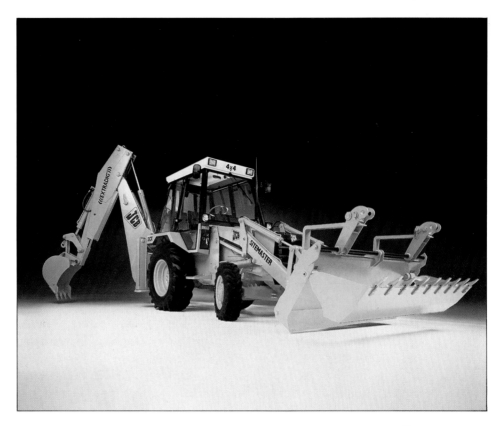

Left The physical bulk of this kind of machinery and the market for it, tend to limit the type of photography that can be used. On occasion, however, eye-catching methods are appropriate, as in a brochure with enough space for several images. An aerial view of machinery at work gives a welcome change of pace.

Cars

THERE ARE THREE MAIN WAYS of photographing cars – as a moving image, in a desirable or beautiful setting and in a friendly domestic situation.

Sports cars are often photographed on the move as cover art. Top-of-the-range, near-racing cars can be shown in sharp focus, against a crowd, with the background blurred. If it is at a race track, the camera will focus on a spot before the car appears, and achieving a good result requires some trial and error. A zoom lens can be used by changing the distance of focus, long to short, as the car approaches the camera. If the clients want the car to stand out in a line of moving vehicles, focusing on the car will set back the other traffic in a natural, unobtrusive design.

How you picture a moving car can be a sensitive issue. Taking a picture that shows speed may be acceptable on a track, but take care to avoid an image that suggests the speed limit is being broken. A more clearly defined background, for example a landscape with car in sharp focus, indicates safety with speed.

The setting for stationary cars depends on the type and market for which the vehicle is designed. Vintage or historic cars often benefit from a location set, with an interested onlooker. Luxury cars may be shown against a stately home background or an exotic far-away holidayscape. Sports equipment and luggage are useful props to convey the capacity of the boot or a hatchback.

Interior shots are a little more difficult to handle. Some photographers have studios specially equipped to photograph cars, but the client may ask for a factory or showroom setting. A wide-angle lens will

■ **This page** As these two results from the same shoot demonstrate, the two critical elements are the ambience of the setting and the quality of the lighting. Wild natural locations are popular for conveying a feeling of escapism (useful for a sports car). Even backlighting without direct sunlight generally gives the best modelling to reflective paintwork – both twilight and cloud fulfil these conditions.

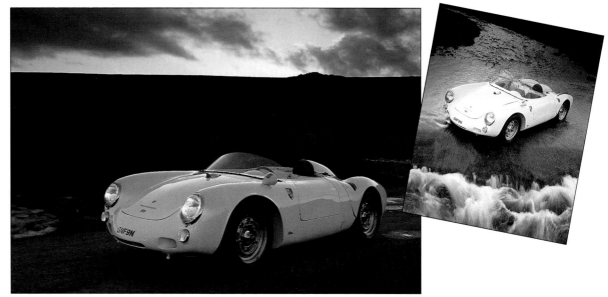

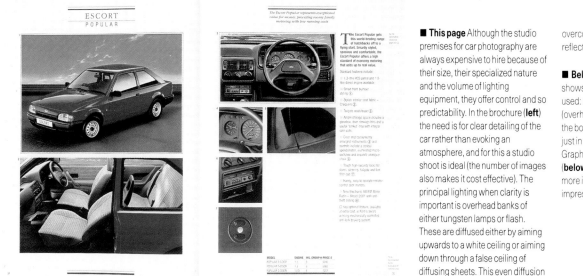

ESCORT
POPULAR

The Escort Popular represents exceptional value for money, providing many family motoring with low running costs

The Escort Popular gets this world-beating range of hatchbacks off to a flying start. Smartly styled, spacious and comfortable, the Escort Popular offers a high standard of economy motoring that adds up to real value.

Standard features include:

- 1.3-litre HCS petrol and 1.8 litre diesel engine available
- Smart front bumper styling
- Stylish interior seat fabric – Chequers
- Tailgate washer/wipe
- Ample storage space provides a glovebox, door stowage bins and a useful 'binhole' tray with integral coin wells
- Clear and conveniently arranged instruments and warmth include a central speedometer, illuminated microswitches and a quartz analogue clock
- Touch high-security locks for doors, steering, tailgate and fuel filler cap
- Handy, easy to operate remote-control door mirrors
- New Electronic AM/FM Stereo Radio – Mixtol 2001 with anti-theft coding
- Any optional feature, available at extra cost, is Ford's latest-working mechanically-controlled anti-lock braking system.

MODEL	ENGINE	INS. GROUP	PRICE £
POPULAR 3-DOOR	1.3	3	6995
POPULAR 5-DOOR	1.3	3	7490
POPULAR 1.8 DSL	1.8 D	4	7977

■ **This page** Although the studio premises for car photography are always expensive to hire because of their size, their specialized nature and the volume of lighting equipment, they offer control and so predictability. In the brochure (**left**) the need is for clear detailing of the car rather than evoking an atmosphere, and for this a studio shoot is ideal (the number of images also makes it cost effective). The principal lighting when clarity is important is overhead banks of either tungsten lamps or flash. These are diffused either by aiming upwards to a white ceiling or aiming down through a false ceiling of diffusing sheets. This even diffusion overcomes the problem of reflections in the paintwork.

■ **Below left** The photograph shows the secondary lighting often used: strip lights positioned far back (overhead and at the sides) to outline the body, and a long white reflector just in front of the camera. Graphically composed detail shots (**below**) are an alternative when it is more important to convey an impression than hard information.

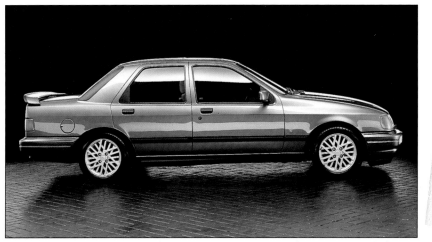

FAST

FOUR

be required, and hidden lights fitted in the roof or other areas out of sight of the lens. Doors may have to be removed to show interior instruments in close up detail. In most cases, the cars will be shown clean, shiny and full of reflections. Sporting cars may be shown twice in a brochure – mud-spattered in a rally and shining bright and clean – but this is not a usual requirement. Most cars can be photographed in full sunshine, with a lamp or two to help if the sun stays away on the day. Try to find interesting patterns from nearby buildings, trees or street furniture.

Distortion – the attempt to make very small cars look large by a long perspective – is less used for the actual shape than was the case during the 1950s and 1960s as it was found to be counter-productive. Nowadays the style is a more realistic, natural approach in all photography, although some distortion may be necessary to include all of the car in the viewfinder. A better result will be achieved by details and good, well-defined views of the car from different angles. Highlights or stars to give sparkle to the brightness should be used with caution

Photographing a town house

■ **Right** In this type of feature, there is always a need for an exterior establishing shot, even if the interiors are more important. Here, a virtue was made of the architectural photographer's common problem of converging verticals. A strongly upward-angled shot with a moderately wide-angle lens emphasizes the narrow façade.

THE SUBJECT TO BE PHOTOGRAPHED was a 19th-century terraced town house in London. The owner, a designer, had converted the property back from the multiple-occupation dwelling that it had become in the 1950s to a single-unit family house. He and his wife had done most of the work, and they were proud of their achievement, so when the magazine that wished to feature the interior approached the owners for permission to photograph it, they were pleased to agree, and a date was fixed for the photography.

The art director knew the house and was aware that it would present a challenge, because it was narrow and on five floors. The magazine wanted to impart this characteristic, but it also wanted to show how the house had been opened up inside to create a feeling of greater space. The narrowness of the house was illustrated by taking the sharp perspective view of the exterior, with the photographer standing close to the railings at the front and looking upwards. The shot emphasized, dramatically, the character of the building.

The photographer used artificial light for all the interior shots. The colour work was completed during the morning, and the black and white work was done in the afternoon. The shot of the interior of the hall, taken from the top of the stairs, reiterates the narrow theme. Views of the first-floor living room, running from front to back of the house, give a feeling of space, which was captured by a long shot.

The studio at the top of the building also extends for the entire depth of the house. Here, for practical reasons, all the furniture was arranged against the

■ **Below** The exposed post and beam work in the study is clearly an important feature, and was emphasized in the photography by lighting the far end of the room. The central post, in fact, conceals a strong photographic lamp.

■ **Right** In the cramped main bedroom, the photographer has concentrated on the owner's wall displays. In this picture the camera has been positioned so as to frame the displays on the opposite wall in the mirror.

■ **Above** Cropping the picture to the top of the chaise longue keeps the viewer's attention firmly on the wall display, with the curves of the furniture adding compositional interest.

paint stripper and, finally, with bleach.
Strong colours were chosen for the ceilings, which are about 12 ft. high, to "lower" them. In the main living room on the first floor, Hugh Marshall spent two days with a small brush, painting a 1-in. strip right round the cornice to produce an absolutely straight line. This done, his wife Anne cheerfully took over, using a large brush to fill in the centre as in a child's colouring book.
On the top floor Hugh Marshall, a freelance illustrator whose work has often featured in *Homes and Gardens*, has his studio. Here a wall was removed to give greater space and light from windows at each end. Through one of the windows, at night, there appears to be a lighthouse winking—but, in fact, this is a distant view of the post office tower. Surprises abound. An expensive looking piece of modern sculpture in the living room is, in fact, made from egg boxes sprayed with silver paint. In the same room six weeks was spent on stripping the "antique" bookcase, bought in a junk shop, to produce its present warm colour.
In the minute back garden (which once housed half a piano and the engine from a Mercedes!) are odd bits of sculpture that the owner has either collected or made. I was lucky enough to spot Voltaire's head hiding among the bushes!
All this basic work took six months. When it was completed and the furniture installed the result was a delightful atmosphere created by ingenuity and good taste, rather than by money.

*Opposite: top floor studio with its supporting "arch".
Above left: a detail of main bedroom, showing one of the lovingly restored fireplaces surrounded by part of a collection of souvenir and ribbon plates.
Left: an interesting still life made from old keys hangs with a variety of family photographs and drawings by Hugh Marshall on a wall of the main bedroom.
Above: exterior of the house, which was built to lasse new and the up stock brick (or London brick).*

28

29

■ **Left** For editorial features, there is not normally sufficient time for the art director to visit the location and the photographer usually works alone. Layouts, therefore, often have to make the best of the pictures delivered.

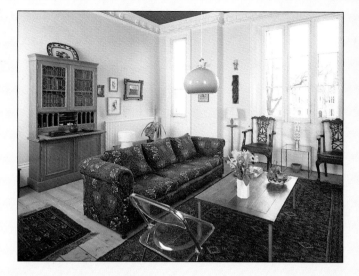

walls but to avoid an empty-looking photograph, the bentwood chair was moved from its usual position by the drawing table and placed centrally. The curves of the chair form an interesting contrast to the straight lines of the pine ceiling supports. The art director made a feature of the triangular shadow on the ceiling, noting the relationship to the diagonal walls at the front of the studio. A series of verticals, horizontals, diagonals and curves form a perfect composition. The house opposite, framed in the narrow attic window, completes the picture with an amusing touch.

When a photograph is taken by a mirror, the reflections must be taken into account and used as an element in the composition. This was done to good effect in the shot of the fireplace surrounded by plates, with a still life showing as a reflected image. When you are directing the photography of any house, remember that it is useful, both from the layout point of view and to give a proper impression of the settings, to have a mixture of long and wide angle shots, as well as close-up details.

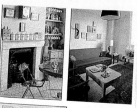

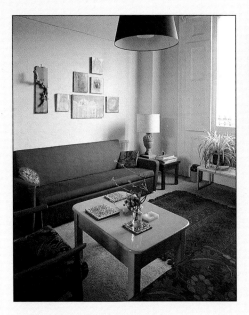

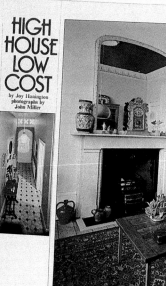

HIGH HOUSE LOW COST

by Joy Hanington
photographs by
John Miller

When Hugh and Anne Marshall decided to move from Essex to London in 1970 they found a house in a square which was designed by a "church" architect—a friend of Pugin. The houses are narrow and very tall preventing a somewhat "ecclesiastical air."

The new owners were faced with many problems, as the house was in a very poor state of repair, having previously been in multiple occupation. They decided to store all their furniture and move in the whole family, which consists of the parents, three sons and two bouterous dogs, and literally set up camp in the ground floor.

This spartan existence was later relieved a little by the installation of a colour television set!

One of their first tasks was the removal of 11 gas cookers and as many Butler sinks. Owing partly to lack of funds but mainly because they relished the challenge, the Marshall family decided

to do most of the restoration work themselves, calling upon professional help only for such things as installing heating, damp proofing, electrical work and the exterior painting.

All the floors were covered with old lino and bits of rotting carpet. To rid themselves of these they

formed a "human chain" and passed down armfuls into the small back garden where a fire was kept burning for three weeks! While they were delighted to find all the fireplaces still intact, restoring the marble to its original condition involved many hours of patient work with blade,

Far left: the long, narrow hall, with its single light shaded by a 19th-century Spanish bird cage.
Left and below: the living room which runs the whole length of the first floor. Gourds in the fireplace were grown by the family when they lived in Essex.
Top: two views of the ground floor—kitchen/dining area (left), and the cosy television viewing end.
Above: Hugh Marshall's paintings on the landing.

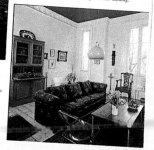

■ **Left** In order to enliven the layout, the art director has surrounded the main room interior shot with smaller images. An experienced interior photographer will anticipate this and provide as much variety of scale as possible. The narrow cropping of the hallway is a natural treatment in a feature that discusses the narrowness of the house.

PHOTOGRAPHING FIGURES

THE HUMAN ELEMENT in a photograph can serve a number of purposes. The person may be the prime subject of the picture, as in a portrait used to illustrate a magazine interview; at the other extreme, the figure may form only an incidental element in a shot for a product catalogue. Your approach to the job of art directing a photograph with people should be largely determined by the context in which the human figure is to be used.

Human relationships play a vital role in photographing people. For this reason, perhaps more than in other types of photography, you need to allow the photographer to work as independently as possible so that you do not cause a distraction or tension that disrupts this rapport. As art director, you have to create the circumstances in which the photographer

and the person being photographed – whether a model or other photographic subject – can together produce an effective photograph.

This means that selecting the right photographer for the job is especially important; as are the preliminary discussions and written brief. Depending on the type of project, you may also be involved in the practical aspects of setting up the shoot – selecting and booking models and locations, for example – but once the shoot is in progress it is usually best to let the photographer complete the session without interference. Your involvement will restart with the selection and editing of the photographs produced.

For most types of figure photography, it is important that the subject is at ease. Many people do

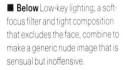

■ **Below** Low-key lighting, a soft-focus filter and tight composition that excludes the face, combine to make a generic nude image that is sensual but inoffensive.

■ **Right** For a successful photograph of people in a working environment, it is important to establish the kind of activity and to animate the people. In an office setting there is less obvious activity than on, say, a building site. It usually helps to set up an active, expressive conversation.

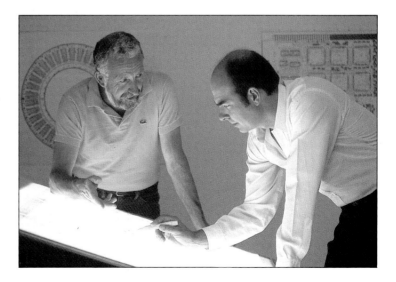

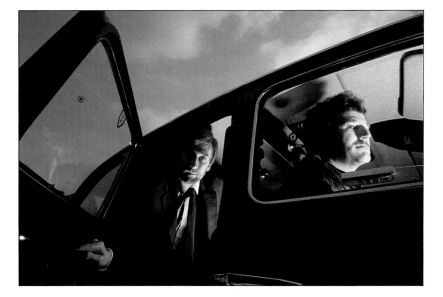

■ Right Lighting and camera angle have been used in this photograph to inject interest and visual excitement into an inherently ordinary situation – a London cab ride. A single flash unit was aimed through the opposite front window of the cab and the shutter speed increased so that the exposure for the daylight was four times less than normal.

not like being photographed, and, if this is the case, it will show very clearly in the final picture. This may be the effect you want, but if not, you will need to try to establish a good atmosphere. Make your subject feel at ease – try to interest them in all the proceedings.

■ Right Drama of a different and more explicit kind is the whole purpose of this photograph for police recruitment. Part of a series of "real-life" situations, it relies heavily on shock. Black-and-white was used to give an impression of news journalism, and, although the situation was staged, a well-known war photographer was chosen for his ability to catch a moment that is both perfectly timed and apparently realistic.

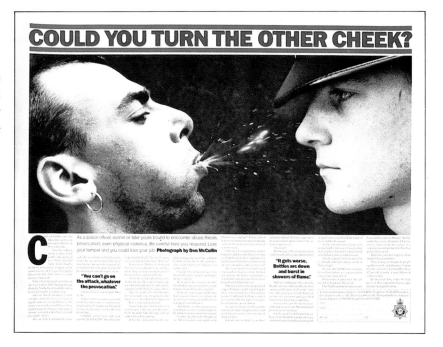

COULD YOU TURN THE OTHER CHEEK?

Models

PROFESSIONAL MODELS ARE USED for many figure photography projects. They are experienced in posing for the camera and are more likely than amateurs to interpret the requirements accurately.

Professional models are based in the major international cities. Model agencies often have specializations such as younger models (15 to 25 years old), hand models, or feet or leg models. They often have separate divisions for male and female models. In London there are even agencies specializing in extras for crowd scenes – (i.e., ordinary looking) – and even "ugly" models with facial peculiarities!

Models have cards showing a selection of photographs of recent work, but, by the time they are printed, these are often out of date, so it is worth having a check-list or questions to ask the agency "booker" by telephone, or you may find that your long-haired blonde is now a short-bobbed brunette.

This is particularly true of younger girl models.

If asked, most model agencies will send around a book of tearsheets from magazines that your chosen model has appeared in recently. It is always worth checking if a photographer has used a particular model before so that any personality clashes can be avoided. It is almost certain that the photographer will have a small circle of models with whom he enjoys a rapport, and you should take this into account when deciding on the overall approach.

It is sometimes preferable to let the photographer do a casting for an important shoot so that you can see exactly how the models react to his style of direction. This can be done on Polaroid or, increasingly, on video and the photographer will charge you an hourly fee for the time he spends casting. This approach can save you a lot of time waiting around on model appointments.

It is important that the model feels part of the team on the shoot and not a highly paid extra. You should brief models with a visual showing the desired end-result so that they feel their contribution is valued as highly as that of the other contributors and that they understand the objectives of the shoot. After the shoot, remember that it is essential that the model signs a model release form (see page 26).

■ **Below** Model agencies produce cards for individual models, catalogues and posters. These are the first step in most selection procedures.

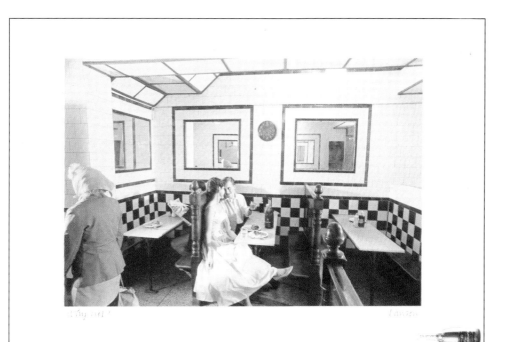

■ **Right** In a candid, reportage-style photograph like this advertisement for champagne, the models have to be able to act sufficiently well to appear natural.

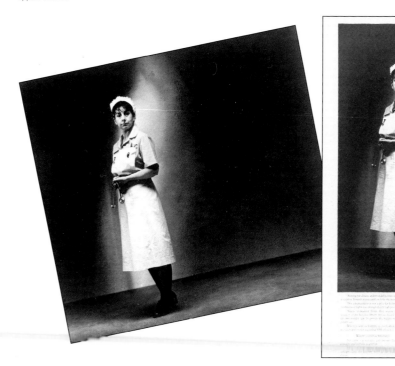

She's poorly paid, works unsociable hours and has a very demanding job.

But that's the least of her worries.

■ **Left** The editorial treatment chosen for this advertisement meant selecting a model who would look the part – overworked, slightly harassed and unglamorous. Character models like this are usually handled by specialist agencies. Styling (crumpled uniform), lighting (overhead to emphasize bags under the eyes) and make-up (disordered hair) complete the effect.

Children

CHILDREN ARE GENERALLY CHALLENGING SUBJECTS to work with. They normally enjoy the experience more than the art director does, but they can get bored if the right approach is not adopted, and the day may have to be geared to their wishes if the photography is to prove a success.

For many purposes, a candid camera style is the most successful. Let them run around with the photographer taking many reels, which will need sensitive editing later on. The studio may have to be cleared of the more expensive items of equipment and plenty of refreshments, toys and drawing materials provided. Children like dressing up, and a good wardrobe of varied clothes will help to make the day run smoothly for everyone. Working on location in schools and playgrounds is often easier.

Children are naturally curious and like to ask questions and talk. A simple running commentary will keep them happy and informed, and better, lively photographs will be taken. Keep the sessions short and try not to lose your patience, otherwise the rapport will be lost and never regained.

Outdoor photography can be a great success. Find a garden you can use and a day's shooting on a sunny day with children will provide a full folio of natural pictures. Bright clear lighting may be the most effective. Child subjects don't need clever or complicated lighting or settings; their own natural attractive looks and behaviour are usually best described with a simple treatment.

■ **Right** As the out-takes reveal, the two children's attitudes and expressions are much less predictable than those of the young woman, although all are models from an agency. This shot for the title photograph had to be taken to a planned layout, using a camera fixed on a tripod. In this situation, part of the woman model's job was to keep the children in place.

HOW TO WRITE AND ILLUSTRATE
CHILDREN'S BOOKS
AND GET THEM PUBLISHED

CONSULTANT EDITORS:
TRELD PELKEY BICKNELL AND FELICITY TROTMAN

■ **Left** This cover design for a book on children's book illustration, called for mixing live photography and crayonwork. The two girls were first photographed on colour negative film without concern for the background. A c-type print was made, and then prepared by airbrushing out the surrounding in white. The illustration was then worked on top of this and the result presented as flat artwork.

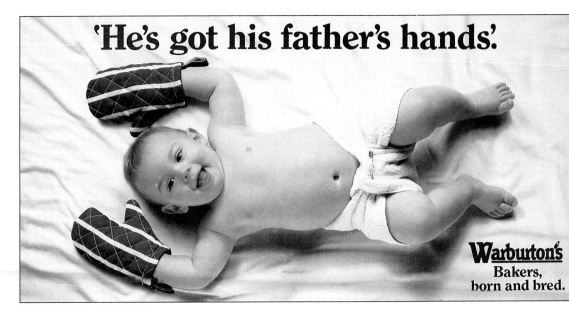

'He's got his father's hands.'

Warburton's
Bakers,
born and bred.

■ **Left and above** Even in a relatively straightforward photograph like this in which little more than a babylike pose was needed, there is no guarantee that the baby will perform to order. In the event, after many rolls of film, no single frame satisfied the agency and client, and the upper and lower halves of two separate transparencies were combined by retouching.

Portrait photography

PORTRAITS FALL ROUGHLY INTO TWO CATEGORIES: the subjective and textured dramatic kind, and the objective, realistic variety. Some famous photographers, (for example Norman Parkinson and Karsh) have developed the former to a highly sophisticated art form, using the subject as human landscape. Others, such as Snowdon, are more detached in their approach.

Your assignment may be the powerfully formed face of the director of a company, whose company report you are art directing. Dramatic lighting may provide just the right effect to depict the man's face, showing his drive and his determination. The cover for a young women's magazine is likely to feature a woman's face, evenly lit and toned, with which most readers will be able to identify. These are extreme examples, but both likely subjects for an art director to create.

When photographing a famous personality, it is

■ **Right** A direct, full-faced studio portrait with the subject looking straight to camera is the least complicated and most predictably effective type of magazine cover image. It is the staple of fashion and personality-interest magazines. Mastheads are usually designed to be legible over the top of the head so that the face can be run as large as possible.

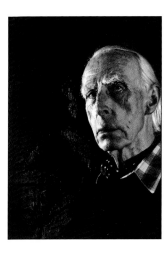

■ **Right** Strongly textural lighting is used for the cover of a newspaper supplement to make the most of this strikingly lined angular face. The main light is undiffused from behind and to one side of the subject. A second, weaker and diffused light fills in shadows from the front. The photographer deliberately left a large area free at the right to allow the art director choice in cropping.

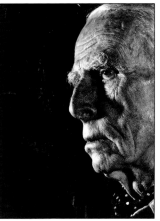

■ **Below** Photography used inside a magazine can often afford to be less conventional than that for the cover. The audience for this avant-garde magazine expects unusual imagery and this arresting portrait – both in gesture and lighting – is entirely appropriate for the market. To emphasize the hand, the photographer has used a fairly wide aperture to throw the face slightly out of focus.

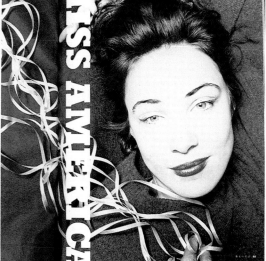

Mary Margaret O'Hara's startling debut album made the 1988 Top Ten lists of most music critics, but chart success has so far eluded her. An upcoming British tour and a new single this month are sure to change all this.
INTERVIEW ANDY DARLING
PHOTOGRAPH ERIC GAUSTER

helpful to study any existing visual material, both photographic and drawn, as a guide to a possible approach to the person concerned. In general terms, young women should be lit in a more full-toned, even light, while older women benefit from some shadow and dramatic lighting. Men of all ages, on the whole, take a bolder, harder lighting.

Most portraits are three-quarter face, but if the sitter has a fine profile this may be a suitable viewpoint. The hair should be carefully studied and make sure, particularly with a female subject, that it does not cast an ugly shadow across the face. Fair hair can form a glowing frame to a pretty face if it is carefully lit and shot in soft focus. The pose is very important. Some sitters collapse in a chair and are better observed standing. Others look relaxed and natural when seated.

■ **This page** One of the most common types of portrait photography is of people and the things they make or with which they are associated. In this example, promoting a young designers in industry scheme, the art director's brief to the photographer was to juxtapose each designer with an item relevant to their job placement, as imaginatively as possible.

■ **This page** One of the aims of a promotional brochure for a large fine arts dealer in London was to establish confidence in the firm. One of the visual methods that the art director chose was to commission portrait photographs in the style of oil paintings.

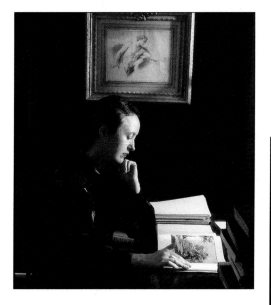

■ **Right** A second spread from the same brochure as above shows the consistency of the photographer's approach, on which the art director has relied heavily. The poses are studied and deliberate, the lighting low-key and colours subdued.

Nudes and glamour photography

THE MARKET FOR THE PHOTOGRAPHY of nude or semi-nude figures is, as far as the art director is concerned, likely to be for magazines or advertising. It is a delicate area, and it is becoming increasingly popular for UK models to request a "closed" set, where the only male person allowed to see the model unclothed is the photographer himself. This may have some bearing on whether you use female photographic assistants, as the inconvenience of the model vacating the set each time a lighting or set adjustment has to be made is great. Much of the work will be with a photographer who works with models on a regular basis and sells, direct to newspapers and periodicals, individual pictures or folio sets. The models will be attractive, young women with well-proportioned figures. A natural style photography is much favoured these days, with a use of lighting and colour that enhances the form of the figure and texture of the skin.

A variety of lighting styles can be used. You can use bold, dramatic lighting that is sculptural in quality. The model is photographed as form and tonal relationship. Sometimes shadows are projected onto the image to produce an almost abstract painterly quality. This kind of work suits a model

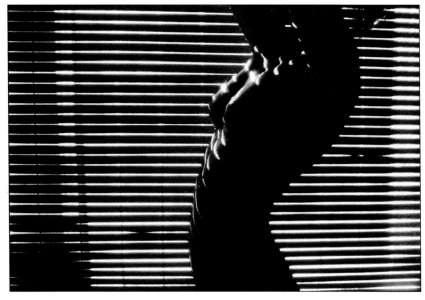

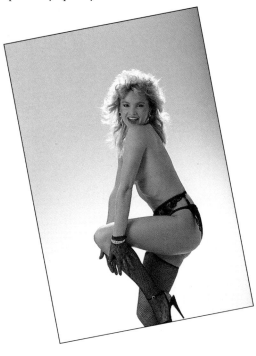

■ **This page** Nude and glamour photography covers an exceptionally wide range of styles. **Above** In this shot venetian blinds create an abstract effect. **Right** A more conventional and realistic treatment uses studio lighting to glamorize the image. A high spot behind highlights the hair and soft graduated background lighting gives depth.

■ **Below** A sculptural treatment for a male torso uses tight cropping, a studied pose, and two-tone lighting, with a spot at far left to define the outline.

■ **Right** Two white flats, a white venetian blind and limited props create a simple set in the studio. The flats also perform the function of reflectors.

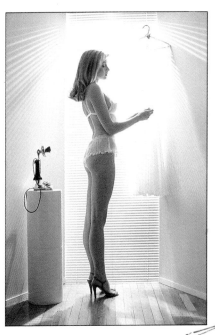

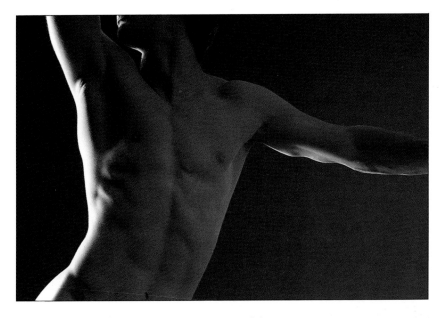

■ **Below** The soft atmosphere comes from the combination of a diffused window light, the pose of the model and a soft-focus filter. The set is deliberately restrained.

who is elegant, fairly tall and has a good bone structure. Another style is natural in lighting and approach, with domestic setting and generalized colour and tone. The pose will reflect this style, and the model tends to look like the girl you might meet on a beach.

Modern cameras and film have made it unnecessary for the model to remain rigidly still. Polaroids can be useful in finding the best pose that will suit a particular model, who can move about the studio while the photographer is taking Polaroid shots. When these are developed, they will give a good indication of what is successful in composition and can help the model in the final photography. Some photographers set their models against complicated

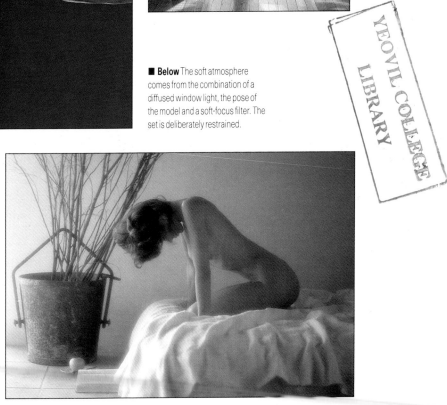

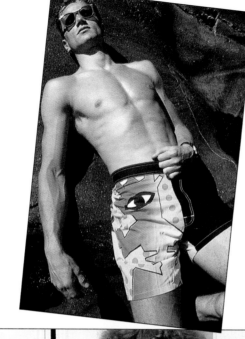

■ **Left** Precise, geometric composition mirrors the strong design of the swimming trunks, while the choice of dark rocks as a background helps to make the colours stand out clearly.

■ **Below** While commercial nude photography does not usually imply overt sexuality, photography for some magazines and calendars is deliberately erotic. An unrelated setting such as a runners' changing room can provide an unexpected contrast to the naked figures.

props and equipment but care must be taken not to make the model look ridiculous as this would be counter-productive.

Location work, although expensive, is suitable for this type of photography. A warm beach with rocks and foliage is generally all that is required for a perfect scenario, and many fine advertising shots and calendars have been based on this concept. Art directors who work in this area of design should make sure that they know both the market and the client who will use the pictures thoroughly in order that they look attractive and are in good taste.

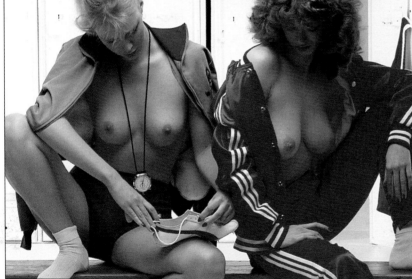

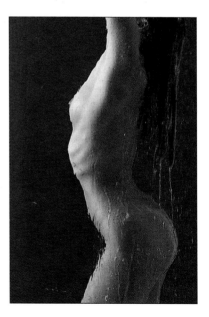

■ **Right** Special effects, as in this photograph shot through a wet glass panel, can often add interest and originality to an image. The dominant side lighting clearly defines the figure against the background.

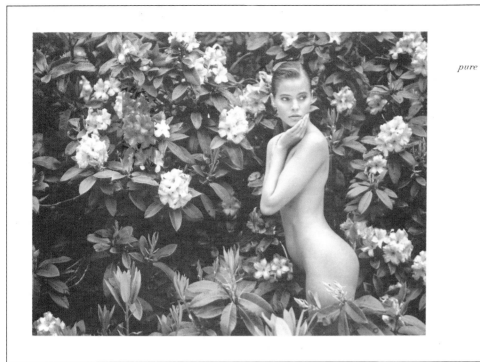

pure

■ **This page** Advertising make-up aimed at a young, environmentally conscious market, these images take a delicate, natural approach, with a young model photographed on location and no attempt at obvious sexuality. Retouching of black-and-white prints carries the eventual message: that this brand has no additives, just colour.

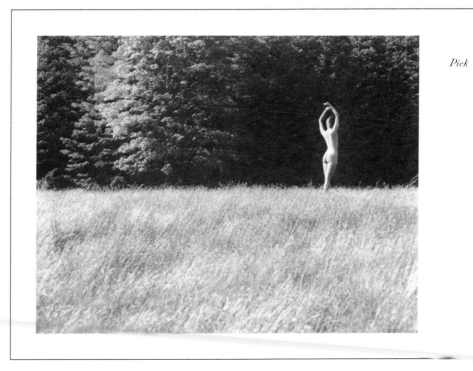

Pick

Calendars

FOR MANY YEARS calendars have been regarded as a market for good location photography featuring glamorous models. As is usual with all location work, good weather is the major consideration, and overseas venues with a low rainfall and high record of sunshine are, therefore, in demand. This will put up the budget alarmingly – transporting the director, the photographic team and six models across the world can be very expensive. You must make sure that the client is prepared for this and the whole project justifies such an outlay before the actual work begins.

The tyre manufacturers, Pirelli, produced one of the best known of these exotic calendars and considered it a worthwhile expense for about 10 years. The calendars were not sold on the open market but given to clients, a practice that created a black market, with calendars often selling for £100 each. An important part of the Pirelli tradition has been to create for each year an imaginative and different theme. This is essentially glamour photography with ideas, and the publicity operation surrounding the launch of each calendar hinges on novelty. As a result, considerable thought goes into choosing photographers who have distinctive styles.

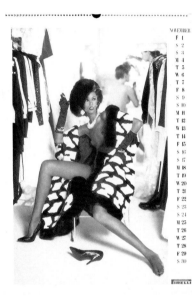

■ **Left** For the 1985 calendar the theme was behind-the-scenes at a fashion show (a reason for the models to undress). Norman Parkinson, a highly experienced fashion photographer, was a natural choice.

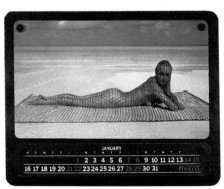

■ **Above** The 1984 calendar was based on a clever, if contrived theme: using the motif of the Pirelli tyre tread in 12 different ways with models on a beach. Photographer Uwe Ommer was chosen for his experience and ideas in adding touches of surrealism into glamour photography.

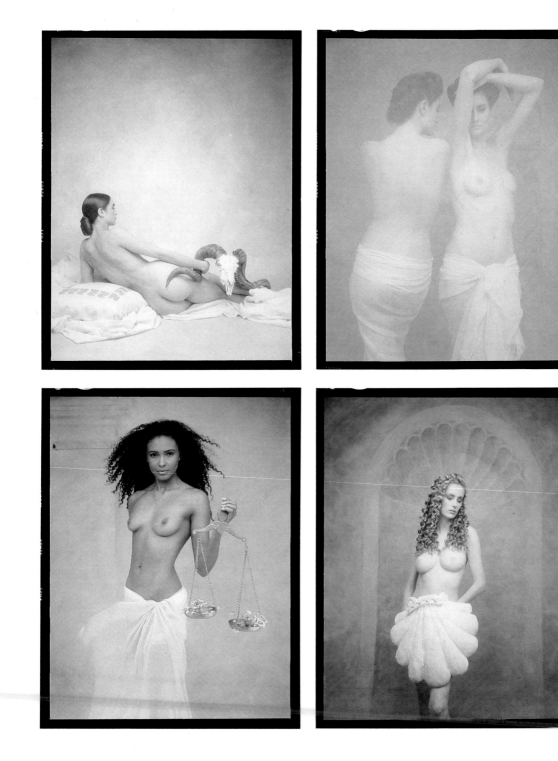

■ **Left** The zodiac theme of the 1989 calendar, featuring the work of the photographer Joyce Tenneson, is not original, but the entire treatment, from choice of models to backgrounds is a pastiche of classical romanticism. This is even reflected in the change of photographic process: a special 24×20 in Polaroid camera. The results have the hallmark of all Polaroid instant prints, a diffuse silvery haze overlaid on a sharply detailed image.

Fashion photography

FASHION PHOTOGRAPHY can be divided into two broad areas – catalogue and high fashion work – and the main difference between the two is the models. For catalogues, models are selected with the customer in mind. They will have average looks; their hair will be styled in the manner seen in popular mass-circulation magazines, and their figures and height will correspond to those of the average woman. The manufacturers and retailers, who are the clients, want their customers to be able to relate to the photographs in every way. This is a vital element in their sales strategy.

The first meeting between the client, art director and photographer usually determines the contents, layout and how the sections will be divided among the different items of clothing – skirts, blouses, jackets, coats and so on – and how many outfits will be photographed in each section. Other stylistic considerations are also worked out before shooting starts, and the client may want some of the fashions to be shown on location and express a preference for the type of locations to be used.

The art director and photographer meet again to organize the allocation of days for studio and location photography. In the run-up to the shoot, alternative sites may be selected for location work and the models booked from the agency; stylist and make-up artist are selected; and transport for models and equipment to the location is arranged.

The day before the shoot begins, the garments will have been arranged in order for indoor and outdoor photography. For the location work, the vans are loaded with all equipment and the team and models are driven to the chosen venue. The photographer will utilize all available light by working on the outdoor shots first before the light fades. This is a very important consideration when shooting summer fashions, because the actual catalogues are generally designed and photographed in the autumn or winter.

Rest periods for the models and food and drink breaks must all be allowed for and taken into account over the total period of time given to the location photography. Weather and travelling can prove exhausting experiences for the team, and it may be found that less shooting is possible outdoors than in the comparatively stable temperature and

■ **Below** Black and white offers varied opportunities for graphic experimentation as in this spread. A large sheet of mylar behind the model acts as a distorting mirror, but this has then been printed in the darkroom so as to remove all other details.

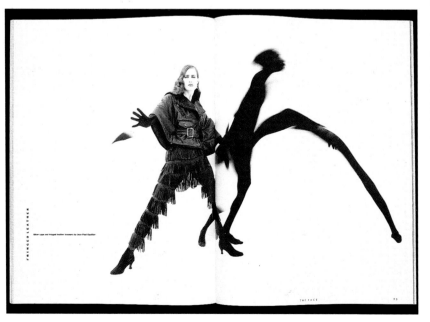

■ **Left** Avant-garde fashion demands unusual picture treatment. The shock effect of this cover is achieved by a ground level shot with a very wide-angle lens, some contortion on the part of the model, and a visual joke with one boot, which is worn on a hand.

High fashion is about ideas and style, and the models translate that style into form. High fashion models are likely to be tall and slim, with distinctive style and looks. They are sometimes taken under the wing of high fashion photographers and will work almost exclusively for them, and this can be an advantage to the client, because model and photographer will develop a rapport and will be sensitive to each other's ideas and method of working, which can save both time and money. The tension and feeling of excitement that run through a high fashion shoot should be communicated to the viewer by the best photography.

A session for a magazine will start early. All the

■ **Below** In this opening spread from the same magazine, the provocative and aggressive style of photography is used as a selling vehicle in its own right and receives equal billing with the clothing. A more traditional, sedate style of photography would have been out of keeping with this style of fashion.

comfort of a studio. The make-up artist will keep a watchful eye on the models, while the stylist will be ever watchful of leaves falling on summer frocks or any autumnal signs that might, unnoticed, give the catalogue buyer a clue to the unseasonable time of year the photography was executed.

When the work is complete, a further meeting will be arranged between the client, art director and photographer. If no re-shooting is required, the pictures will be scaled and cropped and sent for reproduction.

High fashion photography, unlike catalogue work, is likely to be supervised by the fashion editor rather than the art director, whose role will be in the selection and layout of the final photographs. However, as art director, you should be aware of what is involved in high fashion photography and of the demands and constraints of this type of work.

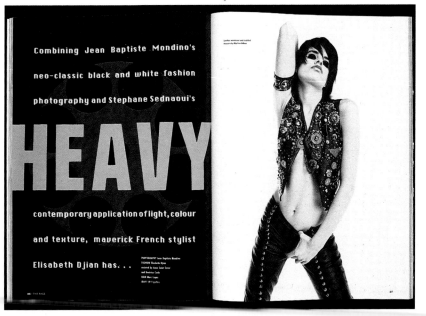

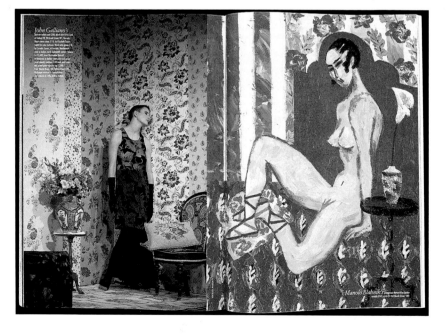

garments will have arrived the day before, and the stylist and the make-up artist will be on site before the models arrive. The make-up artist will want to inspect the dressing room to see that lighting is satisfactory, there is plenty of hot water and a hair dryer, and the stylist will check the dresses to be used and make sure that they are in order of shooting.

The studio may be part of the magazine building, although this may only be possible if the shoot is scheduled for day. Generally, studios belonging to publications are used for the magazine's daily work-load of still life and small cookery photography, which are undertaken by staff photographers. The photographer and fashion editor – sometimes the art director – arrive and discuss the day's photography. A theme may be a feature of the design and all the necessary props will need to be in position or ready for the various shots. Photographers who are well known for their fashion work may want to devise their own scheme of composition, and this will need to be fully discussed at the planning stage. In practice, a compromise between the views of all concerned will be the most likely result.

■ **Above** Even with the basic styling decided in advance, it is normal in fashion work for the photographer and model to try a variety of poses and gestures.

■ **Below** In the spread for *Tatler* magazine, the art director has superimposed one *trompe l'œil* effect on another. In the photographic set on the left-hand page, the floral tunic and skirt are mimicked by wallpaper strips and upholstery. This is then taken a stage further by running it next to a pastiche of a Matisse painting.

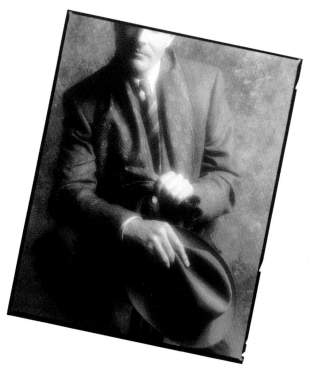

■ **This page** The final selection from a contact sheet of several poses for a shirt advertisement was influenced by composition – in the picture used the position of the hands and neck give a definite structure to the photograph – and by the tidier treatment of the cuff. In these shots and in the print at top left, a soft focus filter gives an impression of lightness.

The models arrive and are made up for the day's work. They are fitted into the garments for the morning session and the assistant takes readings and prepares the camera. If the garments are a part of an important collection, seen for the first time, a member of the fashion house, or even the designer, may call in to look at the photography and make some comments or offer advice.

The session starts and the set will be the scene of great activity and tension right up to the lunch break. Many photographs will be shot of each garment, in many different poses, and the models may suggest some they want to try. At the end of each day the art director will examine a great deal of photography, and from the initial selection the fashion editor will make a further assessment. The process will be repeated the next day and will continue until all the photography is complete and passed to the design department for cropping and scaling, under the supervision of the art director.

Fashion shoot for Cosmopolitan

THIS FASHION SHOOT for the magazine *Cosmopolitan* illustrates the process of designing and executing an editorial feature. The theme was clothing with an ethnic feel. Indian dress, including embroidered tunics, loose pants in light materials, sandals, saris and exposed midriffs, provided the main motif, but the fashion editor was careful to choose clothes that were not too traditional and which could be worn successfully by the western audience for the magazine. The first decision was to shoot in a studio rather than on location. It was felt that the clothes would stand out best against a plain white background. The photographer, Tony McGee, who was chosen on the basis of his previous studio work for the magazine, helped set the style for the pictures. Part of the brief to the photographer was to have the models move and jump to create exotic shapes, but at the same time to show all of the clothes clearly. The shot was loosely art directed, in the sense that, once the two models had been chosen (by the fashion editor, photographer and art director together), the photographer was given a fairly free rein to develop ideas during shooting. One such idea was the consistent use of veils. Following the shoot, the art director was able to crop the pictures tightly in order to enhance the dynamic shapes (the opening spread is a good illustration of this). Had the shots been taken on location, the cropping would probably have been looser in order to include the setting.

■ **This page** The graphic shapes created by the clothes were emphasized by the use of a plain white background.

Recreate this look using colours from Estée Lauder's Signature range Complexion: Polished Performance Liquid Make-up in Ivory Beige with Face Powder in Ecru. Cheeks: Cinnamon Powder Blush. Eyes: shaded with Black Grape/Beaujolais/ Framboise Eyeshadow Trio with Grey Velvet Eye Contouring Pencil. Luscious Creme Mascara in Black/Brown Lips: Lipstick. Clothes as shown on page 164

Embroidered tunics, **midriff** tops and hipster trousers, plus beads, bangles and thong sandals — the scene is set for a **'Seventies** revival. Hippy days are here again — or you may turn into a pillar of fashion history. Like Lot's wife, you should never look back **Indian** accessories, **spice** and acid hues, opulent and *oriental* fabrics add an exotic taste — more **rich** than kitsch — to what has been a fairly bland decade in terms of colour and ornamentation. There is a nod back to *ethnic* footwear — woven **moccasins** and leather sandals definitely looking newer than heels. But beware: *sarongs* are not always so right and *saris* can be just too Indian bazaar, unless a degree of tailoring is retained. Don't let it all hang out in '89, let it hang together.

EXOTICA!

KODAK EPR 6017
EPR ▷ 29 EPR ▷ 30

KODAK EPR 6017
EPR ▷ 16
EPR ▷ 17

Left: T-shirt, £35, Jacket, £125, Whistles. Skirt, £85, Jemyka Jones. Scarf worn as a cummerbund, from a selection at The Moroccan Bazaar. Pumps, £100 approx, Elizabeth Stuart Smith. Tights, £1.30, Pretty Polly. Earrings, £44, Branché. Fabric, Dickins & Jones. Right: Bolero, £513, bra top, £233; skirt, £213; Oztek. Earrings, £8, Baka. Bracelets, from a selection at The Moroccan Bazaar, Clifton, Dickins & Jones.

164

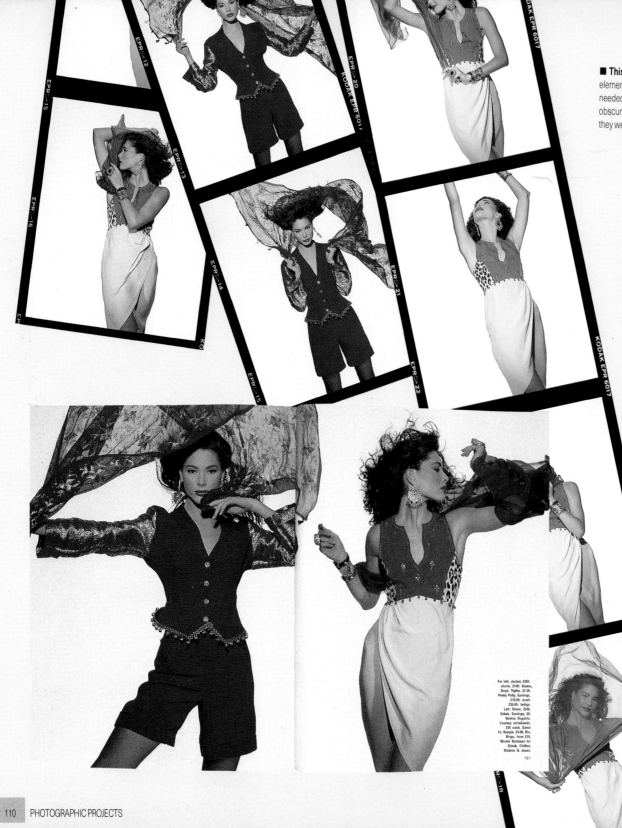

Far left: Jacket, £285; shorts, £145; Karen, Boyd. Tights, £1.39, Pretty Polly. Earrings, £15.50; scarf, £30.95; Indigo. Left: Dress, £545, Ozbek. Earrings, £6. Denise Dugdale. Cowboy wristbands, £35 each, Santa Fe. Bangle, £4.99, Rio. Rings, from £19, Nicola Bateman for Ozbek. Chiffon, Dickins & Jones.

161

Right: Trousers, £152,
Sportmax. Jacket,
£54.95, Jenkyn Jones.
Sandals, £105,
Byblos. Earrings,
£29.95, Gilly
Girls at Harvey
Nichols. Chiffon,
Dickins & Jones.
Far right:
Jacket, £130; trousers,
£55: Whistles.
Sandals, £85 approx,
Robert Clergerie.
Earrings, £19.50;
mirrored fabric,
£34.99: from Indigo.

167

■ **This page** The chiffon seemed to work so successfully in the first shot that the photographer decided to use it throughout. A wind machine was used to make it move attractively, although it meant paying constant attention to the models' hair and created some risk of redness in their eyes.

REPORTAGE

REPORTAGE PHOTOGRAPHY – that is, photographs taken to record actual events and locations – is mainly the province of the photo-journalist, and it can include subjects as diverse as sporting events, state occasions, nature and animal photography, and travel pictures.

Since it is by definition location work and not susceptible to art direction in the composition of the shot, the art director's role in managing this type of photography is largely limited to the initial commis-sioning of the photographer and the skilful selection and editing of the final image. If travel is required, the art director may also need to be involved in making the necessary arrangements.

The choice of photographer is all important since you need to rely on his or her judgement to take the shots you require – it is unlikely that the shoot can be repeated if you do not get the results you want. Often it is necessary to commission a specialist photographer – for a nature shot, for example,

■ **This page** The classic use of reportage photography is the picture story – a format developed by the great pre-war magazines even as *Life* and *Picture Post* and now under-going a revival. The story here is life in a rural area, and the role of the art director has been to select the pictures (from a large number, as is typical in reportage work) and juxtapose them so that they give an immediate impression of place and atmosphere.

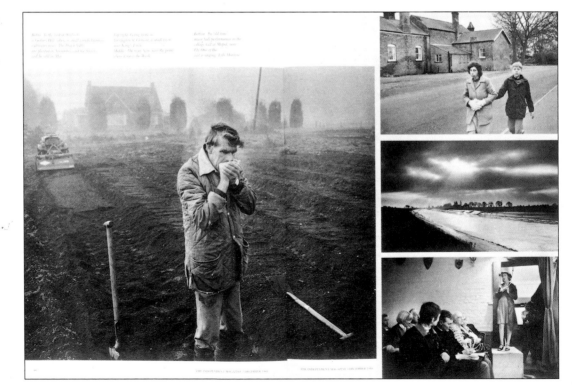

knowledge of the subject is vital to getting the right picture. A photographer who is to take pictures involving people at work should be able to establish a cooperative atmosphere in which the subjects are able to enjoy displaying their skill and crafts-manship. By contrast, other types of reportage involving people may require the photographer to be as unobtrusive as possible in order to capture natural and spontaneous events.

■ **Below** Photographs that capture an unusual situation, such as laughter in a graveyard, depend very much on the perception and character of the photographer. For this article (the same as that featured on the facing page) the magazine's art director intentionally assigned a photographer who, because he was Polish and unfamiliar with the area being photographed, would bring a fresh eye to the subject.

■ **Above** A crowd photograph in darkness provides a challenge for the photographer. The spotlight on the heads of the crowd produces an atmospheric and abstract shot with dark areas over which reversed out type could be placed.

Cityscapes and landscapes

STREET PHOTOGRAPHY can be a subjective medium for a photographic essay, or it can be wholly objective, describing the architecture of a terrace, the condition caused by excessive traffic or the view of a romantic avenue of plane trees in northern France. Each type of photograph can be totally different in both concept and atmosphere. Back lighting, achieved by shooting into the sun, produces a highly dramatic street-scape, suggesting impending doom or tragedy, with the trees and street furniture thrown into shape silhouette. The same street, photographed at noon with an overhead light, will present a normal view, descriptive of the surroundings, cheerfully busy and active.

Decide on the lighting and the time of day. Do you want to show parked cars and people walking about, or do you want a deserted early morning scene? If the photography is to be done during winter, consider artificial lighting to supplement poor lighting conditions. Confine your activity to about six streets and decide how many black and white and color shots you want, and limit the photographic time; otherwise, much time will be

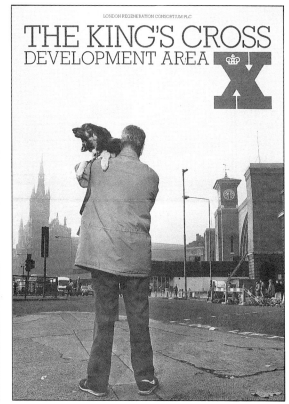

■ **This page** To bring life and interest to a series of pictures of a desolate urban area scheduled for re-development, the scene was photographed from the viewpoint of a resident and his dog. The cover decision was deferred until the photographs were delivered. The preferred image had to be extended upward to accommodate the title.

spent wandering about aimlessly. Two or three hours should be sufficient to provide a good folio for editing back at the studio. Look out for the shape of street furniture (street lights, mail boxes, etc.) to provide strong verticals to break up monotonous horizontals.

Landscapes are less likely to be the concern of an art director than of a photo-journalist. Essentially subjective, they may be part of another project or assignment, for example, a photo session of a house for a magazine or newspaper. The composition presents fewer problems than other aspects of art direction, for trees, hills and rocks join together to generate a natural composition that is almost always photogenic. Landscapes in areas of flat scenery may, at times, appear daunting in their horizontal, spatial relationships, but cloud formation, often a feature of these flatlands, can come to the rescue. A wide-angle lens will capture the transient beauty of these cloudscapes and their bold dramatic changes. Landscape can also be described in detail, using still life groups of the surface and texture of the leaves, rocks and trees.

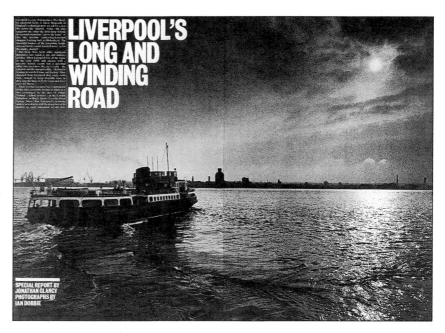

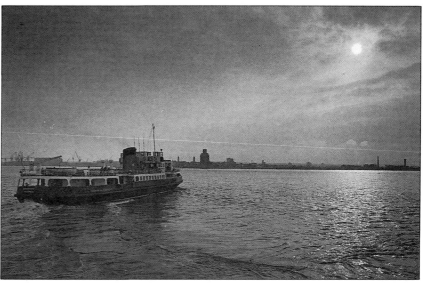

■ **Above** With commissioned landscape and cityscape photography for publication, it is important to brief the photographer on the possible use of text type. As seen in the camera's viewfinder (above), the composition of a shot of a river ferry is too open, but this in fact anticipated the headline and text in the layout (top).

Travel and holiday publicity

TRAVEL PROMOTERS, AIRLINES and holiday companies are all likely to require extensive photography for their brochures, posters and so on. A package holiday company will require photography for brochures showing holiday locations and hotels, and since the art director is unlikely to accompany the photographer, careful planning and thorough briefing are essential.

The timing will be critical since the clients want their money's worth and expect you to cover as large an area of their operations as possible in a relatively short space of time. You will need to plan the programme to the last detail. It will be helpful to talk to those who know the district to find out as much as you can about weather, food, the cost of living and if you can drink the water. A sick team will be useless to everyone. You should also find out if any special customs documentation will be required for photographic equipment or props.

Photography for holiday brochures needs to be a compromise between giving a flattering image of a location that may not be typical and showing the place at its worst – say a crowded resort at peak season – that may be off-putting to clients.

Photographing tall, featureless hotels also presents a problem. Shots from a balcony onto the swimming pool or from a window at an angle, to show some building and beach, may be an answer. Palm trees help to soften the appearance of this type of hotel, but a brand new building can be a very

■**Right** The type of destination determines what kind of appeal it will have to potential tourists. India, an exotic holiday destination, lends itself to the reportage style of travel photography, in which the photographer is given the responsibility of finding exceptional views and nothing – or very little – is set up in advance.

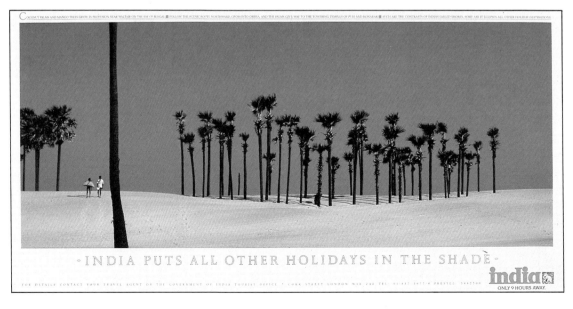

COCONUT PALMS AND MANGO TREES GROW IN PROFUSION NEAR WALTAIR ON THE BAY OF BENGAL ■ FOLLOW THE SCENIC ROUTE SOUTHWARD, CROSS INTO ORISSA, AND THE PALMS GIVE WAY TO THE TOWERING TEMPLES OF PURI AND KONARAK ■ SUCH ARE THE CONTRASTS OF INDIA'S FABLED SHORES, SOME SAY IT ECLIPSES ALL OTHER HOLIDAY DESTINATIONS

· INDIA PUTS ALL OTHER HOLIDAYS IN THE SHADE ·

FOR DETAILS CONTACT YOUR TRAVEL AGENT OR THE GOVERNMENT OF INDIA TOURIST OFFICE 7 CORK STREET LONDON W1X 2AB TEL 01-437 3677/8 PRESTEL 344270#

india
ONLY 9 HOURS AWAY.

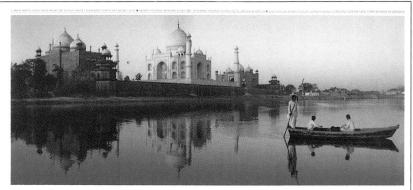

■ **Left** From the same advertising campaign as the poster on the facing page, this photograph of the Taj Mahal combines two essential ingredients for travel promotion: attractive lighting (at sunrise) and figures.

■ **Below** Advertising for the Jamaican tourist industry works on a different principle: it is very much a tropical beach destination. As a result at least one shot must show tourists (with whom readers can identify) with palm trees and sea. The art director's solution is a two-picture advertisement with commissioned photography shot to agreed copy lines.

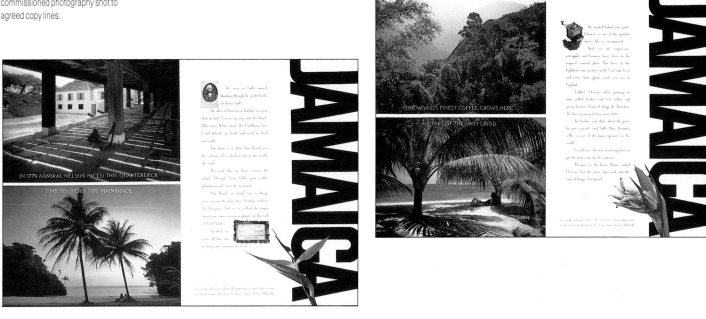

difficult assignment. Photographs from a boat, showing the curve of the beachline with the building portrayed in long shot can also help. Some of the better hotels have exciting architecture, with curved parapets set against straight walls and interesting rooflines, and you should use this type of architecture and its sculptural quality in detail shots

Most holiday pictures show blue sky and sunshine, but this is not the case with walking or climbing holidays. Rolling clouds over hills and moorland may be just what adventurous, activity-based holiday-makers are looking for, and they would not be attracted by unnatural, cloudless skies. Presenting a true picture must always be the aim.

Sport and leisure

MUCH REPORTAGE PHOTOGRAPHY is concerned with people participating in sporting events or other leisure activities. Sport, in particular, has been the subject of some of the finest action photography in the world.

If you are responsible for the photography of a major sporting event, it is essential to plan to cover the event in the best possible way. The stages that take place at any sporting fixture can be divided into three distinct parts – a beginning, a middle and the end or climax. For example, a soccer match starts with the home team running onto the field, with the supporters cheering; the play progresses, a goal is scored, and the climax is reached and the crowd goes wild. This can be replicated in other sports.

Athletics, car races, horse racing, all have their quiet moments and their shattering exciting endings. A good, well-briefed, photographer will be ready to capture all these aspects of the game.

Apart from the actual shots during the action, the background composition helps to build up an overall picture of the event. Pit stops in motor racing, for example, can make telling and powerful supporting imagery.

The close-up is a compelling part of this area of reportage photography. The tough and aggressive-looking boxer, softened by the towel around his powerful head, or the runner, proud but exhausted after his sprint to victory, provide vital pictorial descriptions of the drama and atmosphere that exists in the ring or on the track. The art director will have to make a judgement on how best to enhance these qualities in the pictures presented by the photographer. Skilful cropping, perhaps reducing the background will emphasize the goal scored or the high dive that won a gold medal, while reducing the height of the picture will show the horses spread out along the fence and convey the lengths behind the winning steed.

The sizing of finished prints on the page layouts should be carefully considered. The largest picture in a tennis series might be the winning shot that brought the match to a satisfactory conclusion for the champion. On the other hand, the keen fan might be more interested to see how the outsider put up a brave fight to hold off the champ and the skill displayed in the process.

■ **Below** As in other kinds of reportage photography, the art director must rely very much on the sports photographer's eye and imagination. Shots like the one below, of a Michigan University football game, in which colour contrast makes the photograph, suggest themselves on the spur of the moment.

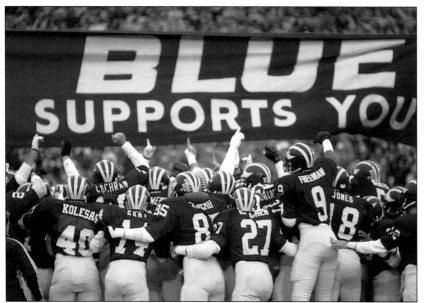

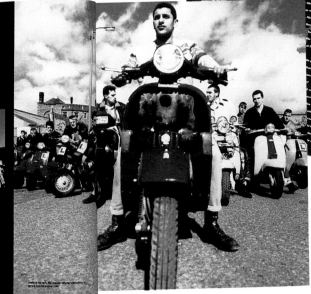

Scooter chic defies all flip categories in Glasgow, where Sean Connery, sci-fi and schlock horror films mix with every youth cult ever chronicled in a head-on culture collision that's more Mad Max than Quadrophenia. Only one style question bothers these mutant magpies –

FREDDY KREUGER WAS A MOD?

R

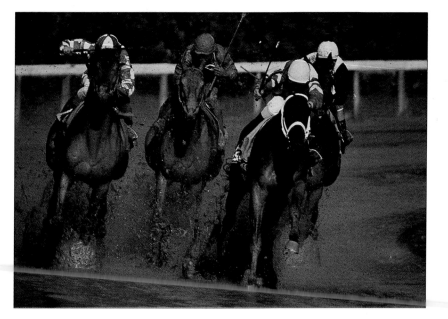

■ **Above and left** Leisure activities inevitably focus heavily on the participants. Unlike the photography of organized professional sport, there is more of an unpredictable reportage element. Nevertheless, in briefing a photographer to cover a subject like this scooter club, the art director should stress the need for variety and plenty of picture material for choice.

■ **Right** Dramatic timing is a key ingredient in most sports photography and for each sport there are certain classic viewpoints and moments. In horseracing, a head-on view of the leaders entering the final straight is one of these, but this shot of a race at Saratoga Springs is further lifted by the spray from a water-logged track.

Reportage magazine feature

THIS REPORTAGE FEATURE article in the *Tatler* magazine used pictures to make a deliberate design point. The art director wanted to convey the eclectic atmosphere of London's Notting Hill Gate area and has used the layout to do this even more than the content of the individual photographs. The brief to the photographer was to bring back a large and varied selecton of photographs rather than spend time on studio images. With this kind of treatment, it is important that the photographer is made aware in advance of the possibility of severe cropping – and does not object.

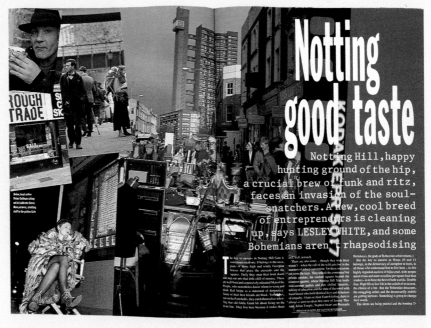

Notting good taste

Notting Hill, happy hunting ground of the hip, a crucial brew of funk and ritz, faces an invasion of the soul-snatchers. A new, cool breed of entrepreneurs is cleaning up, says LESLEY WHITE, and some Bohemians aren't rhapsodising

■ **Right** Intercutting and overlaying creates a kaleidoscopic effect out of images that are straightforward and documentary rather than striking and inspired.

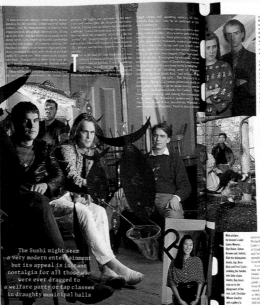

■ **Left** The rebate (film edge) from the street scene above has been included in the design to emphasize the documentary flavour of the article, and the art director has been able to make full use of the white background to the portrait (top left) by running type over it.

⊲ you can be fed pap by the Young Explorers, Simon Browne, James Moores, and Glyn Baker, in the dusty theatre of the Cobden Working Men's Club. There will be four courses, communal tables, live music and possibly Jack Nicholson.

The sushi might seem a very modern entertainment, but its appeal is an instant nostalgia for all those who were ever dragged to a welfare party in a card board hat or to tap classes in a draughty municipal hall. Its huge circular and refectory tables are flanked by fashion lags in beat decorations, Lynne Franks and excitable Bunkers, Terence Stamp, Tim Roth, Dave Gilmour and everyone who ever bought a copy of *i-D*. There is so much table hopping that the delivery of bills is haphazard and people tend to walk away in each others' coats. The venture is low key. 'We didn't want to give out the address,' says Glyn, sometime actor and founder of the Kamikaze Sushi City delivery service. 'Mainly because we can only hold 150, we have to be fully booked in advance because the fish won't freeze and I'd hate to have people standing outside not being able to get in. Everyone has to book first – if they come here we'll give them the number.' Simon the chef buys from Billingsgate at 4 a.m. on Thursday mornings. The fish is rolled into sushi on stage by Japanese helpers, while downstairs darts fly in the Working Men's Bar. Wasn't there just a frisson of tension?

'No, the committee were delighted we wanted to do something with the place, it was in danger of being pulled down. They hadn't heard of sushi, but they knew about ground rent.'

One rank new villain who has no dreams of social reconciliation is 23-year-old Ben Anderson, bogeyman of young Bohemia, the dreaded property tycoon. He has even acquired 12 All Saints Road (from Frank Critchlow, owner of the Mangrove – symbol of all forbidden places in the once no-go ghetto. He plans to turn it into a private bar restaurant, a haven for the radical rich. When Critchlow was arrested on charges of heroin possession, his street was nanmed for a while by the SPG, and fell into a fretful silence. The music and the open dealing stopped. It seemed safe. Where once only a couple of brave white pioneers had dared to read (Richard Jobson had his locks glued up, human excrement dumped on his doorstep, and was only accepted once spotted in a kilt), there now rushed in Simon Oakes, neophyte producer for Crossbow and Marek Kanievska, director of *Another Country* and *Less Than Zero*, who holds lavish Friday night soirées for the Very Famous in his loftspace. Limos line the front line.

But a clever clean-up boy is Ben, middle-class, white and not prone to talk jive. He used never dare enter the All Saints; now he likes it for that 'residual twitchy feeling it still has'. In his company office in Golborne Road – one of many properties he owns about the Hill – Ben feigned surprise at his notoriety. He says his job is just about 'seeing what's round on the streets.' The child of Church Street antique dealers, he left Holland Park Comprehensive at 16, worked for a bit in the rag trade and began buying antiques for Laura Ashley, which he still does. Now a grandee of Chepstow Place, his big fun is a fleet of vintage Pinin Farinas, BMW somewhikes, and the two Fifties speedboats in which he cruises the river.

Bliss is doing the deal: recently a whole Wandsworth mews for £500,000. A man who enjoys knitwear and never eats at home, he is proud to illuminate the gentrification generation. 'Some people saw it coming quicker than others – some got the houses and some got the bedsits. Ha!' Would Notting Hill become too exclusive for ordinary people? He looked as if I was quite mad. 'It already has.'

Up a flight of wrought-iron stairs is his brother, Toby Anderson's Lotown Records operation, an eight-track studio (soon to be upgraded to 16-) and a collaboration of brooding and well-connected young musicians like David Ogilvy, Kadie Gurney, Jig White and the clubland polymath Barnsley. They are boys who talk bass riffs and stare blearily till the girls go wild. The label has just decided to distribute through London Records, while the engaging David has signed to a French record company in Paris, run by a Scotsman, who will license back to Britain. Unusual certainly, but we are in heart of artistic integrity here. In Notting Hill creatives will go in any lengths to be understood. They also like to show they are part of the community. Ogilvy, for example, who 'used to sing country in Denver', plays in the resident group at Tarka Kings' country Congress parties. 'It's like a village round here,' he says of his neighbourhood, 'everyone knows everyone, and we are all involved.' David drinks whisky in the Warwick, but despite his occasional fine art dealings and incipient fame, 'I cannot afford to eat in 192 as often as I'd like.'

Tarka Kings is currently painting David Ogilvy. The nicely fey Miss Kings has a studio 543 steps off Hereford Road and a Tom Dixon chair. She has taken her itinerant Congress honky-tonk ('I was bored of funk') from the Irish club in Belgravia (too posh) to the Maxilla Hall, a working men's club beneath a flyover off Latimer Road and an ideal venue for the chic to rub shoulders with the shabby. Irish regulars share pints with Teddy St Aubyn, Hannah Rothschild, all the Miss Well Connecteds of the Warwick, even – puhleese – the girl from the Timotei ad. 'The young blades get down, play, sing and are dreadful,' comments an aficionado. Still, Tarka has boasted guest artists like ex-Roller Les McEwan and the drummer from Bad Company, and now she nurtures plans to invite Nashville's finest – when she has enough money to guarantee their fees. It looks promising. Who are her posse in studded boots? 'The Warwick crowd, Joe Strummer, middle-class and very white . . . though we did have the black drummer from Ian Dury's band – he was very nice.' As a new refugee from Chiswick, Tarka does not lack a certain sharpness in observing the habits of her Hillbillies. She doesn't go to 192 ('can't bear swivelling heads every time the door opens'), or the Lisboa ('ate too many cakes'), hates local galleries ('full of rubbish'), spits at property prices ('after all, it's a pit'). The local Catholic priest wrote an article saying that the extremes of wealth and poverty here are a microcosm of the world. It's disgusting, not colourful.'

One young gallery man told me that the thing about Notting Hill was that you might get your head beaten in, but that gave life a terrific edge. Two or three wise men said that there would be trouble, like real street trouble, if the big white money pushed one more inch. And it will. The black party scene has gone to Willesden Green. The Star Apple shebeen is now the Kensington Park Road tapas bar, and even Papa Weasel, whose blues were just the best, stays home those nights with his girlfriend. She is a partner in a new jewellery business and thinks Notting Hill needs cleaning up.

Right, laying down tracks at Lotown: Lord David Ogilvy

Right, Tarka Kings, bringing Country to Notting Hillbillies. Left, street livelihood in W11

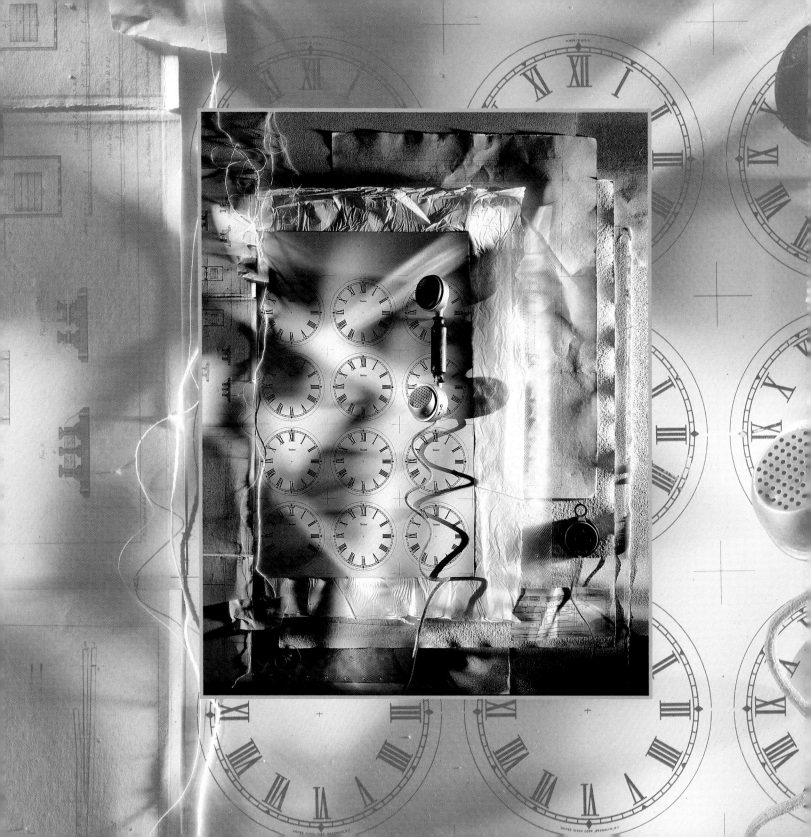

SECTION THREE

EQUIPMENT

AND EDITING

TECHNIQUES

CAMERAS
AND LENSES

THE MOST PRACTICAL CAMERA film formats for advertising and fashion photography are 35mm, 6 × 6cm and 6 × 7cm, but for exceptionally high-quality images, the choice is between 5 × 4in or 10 × 8in view cameras. Medium format transparencies and larger can be roughly assessed on the lightbox, without a loupe, giving them an advantage over 35mm, but all transparencies should be checked thoroughly with a loupe for sharpness before the final selection is made.

SLR

Of the cameras available, 35mm single lens reflex (SLR) cameras offer tremendous flexibility, and a choice of interchangeable lenses. The viewing system allows the image to be viewed the right way up and the right way round through the actual lens that will expose the film. The quality of the image from 35mm film is adequate for most circumstances, up to A4 full-bleed sizes in magazine reproduction. Their low weight and bulk makes 35mm SLRs particularly useful for location work, and they also produce 36 shots to a roll (a 6 × 6cm camera produces only 12) – allowing enthusiasm and rapport to be maintained throughout, say, a fashion shoot.

Medium format cameras offer improved image quality, and the majority take interchangeable roll film holders so that a supply of ready-loaded backs can be on hand to keep a shoot flowing. This facility also lets the photographer switch, in a matter of seconds, from colour film stock to black and white and vice versa.

Moreover, medium format cameras and the larger view cameras can be used for test shots on Polaroid instant film (available in black and white or colour). This helps both photographer and art director to check the pose, lighting, composition and exposure before the camera is loaded with the appropriate film stock.

VIEW CAMERAS

Apart from the superb image quality available from either the 5 × 4in or 10 × 8in formats, the principal advantages of view cameras are the technical movements that allow comprehensive control over perspective and depth of field. The most versatile of all is the monorail, a studio camera designed for still life photography of the highest quality. The best brands of 35mm cameras – Nikon, Canon, Minolta, Olympus and Pentax – all offer a shift lens incorporating limited shift movements for architectural photography.

Field cameras are folding view cameras which, though not quite as versatile as the monorail, are more practical and robust for field use. A technical camera is a studio version of the field camera. A serious drawback of view cameras is that the image appears upside down on the viewing screen.

LENSES

The focal length of the lens used on the camera dictates the appearance of the picture. The 'standard' lens varies in focal length according to the format of camera. For example, a 50mm lens is standard for a 35mm SLR, whereas an 80mm lens is standard for a

10×8in

6×6cm camera. Lenses with shorter focal lengths are known as wide-angles, while longer lenses are referred to as telephotos.

Zoom lenses, unlike fixed focal length lenses, can be zoomed between two focal lengths, say from 70mm to 210mm on a 35mm camera. However, zoom lenses have a smaller maximum aperture than a comparable fixed focal length lens, which can lead to low shutter speed and result in blurred images.

Certain focal lengths tend to give the best result for specific types of job. For example, a lens of 85mm, or up to 105mm on a 35mm SLR, is perfect for a head-and-shoulders or three-quarter-length portrait. The same job shot on 6×6cm would require a 150mm lens to give the same perspective.

All 35mm SLR cameras use a focal plane shutter built into the camera body. Most medium format cameras, on the other hand, use lenses with an inbuilt leaf shutter. This enables flash to be synchronized at speeds up to 1/500sec, a considerable advantage over most 35mm SLRs, which can only synchronize with flash at around 1/60sec. High-speed flash synch gives more options.

View cameras use only fixed focal length lenses with inbuilt shutters, and these are attached to the camera by means of a lens board. The choice of such lenses is very limited, but includes standard, wide-angle and short telephoto lenses.

Some of the lens types (principally for 35mm SLRs) are for close-up photography; *fisheye* lenses for dramatic, extra wide-angle shots showing considerable distortion; *shift* lenses for perspective control; *mirror* lenses for long-range telephoto shots in which out-of-focus highlights turn into shimmering "doughnuts"; *tele-converters* (also called doublers or matched multipliers), which fit between lens and camera body to double (usually) the focal length of the lens in use; and *anamorphic* lenses, which squeeze an abnormally wide angle of view (widescreen) into the film frame.

■ **This page** Shown here all in proportion, the four principal film formats are 35mm (with the sprocketed edges), rollfilm, 5×4 inch sheet film and above 10×8 inch sheet film. Each format is naturally used in different cameras and each has its particular advantages.

5×4in

35mm

Rollfilm

LIGHTING EQUIPMENT AND TECHNIQUES

LIGHTING IS NOT ONLY THE ART but also the craft of good photography. It is vital for an art director to know how lighting can be used to control the mood and balance of the image. Most commercial and advertising work will call for studio-based photography, where lighting can be carefully controlled, rather than location photography, which is subject to the vagaries in the weather if shooting outdoors, and mixed light sources if working indoors.

Electronic flash tends to be the most popular light source in the studio, especially for live subjects, while tungsten lighting is popular for still life photography. Whether the source is flash or tungsten, however, the basic technique is still the same in that art seeks to imitate nature with the so-called *key* light replacing the sun as the main light source, and either a secondary light, known as *fill*, or reflected light providing modelling, balance and softening shadows. It is usually also necessary to light the background. Colour films are either daylight-balanced, for use with daylight or electronic flash, or tungsten-balanced, for use with tungsten lighting. Colour-correction filters can be used on the camera lens to achieve a compromise if the lighting is mixed. Ideally a test shoot should be conducted and exposures made with different filters; but if there is no time, a colour temperature meter can be used to give an idea of a likely filtration package – but it is wise to repeat the shots with different filters to hedge your bets.

If daylight-balanced film is used under tungsten lighting, the results will be unnaturally orange; a daylight picture taken with tungsten-balanced film will give very blue results. Both these aberrations can be used deliberately to create moods, such as orange for a feeling of warmth and comfort, and an unnatural blueness for a feeling of coldness, starkness or hostility.

When working outdoors, photographers use fill-in flash or reflectors to add light, to brighten shadows or subdue contrast, especially with basically backlit subjects. Reflectors can be white, silver or gold in colour – a gold reflector can add warmth to skin tones in colour work but reflects less light than a silver refector. Coloured gels can also be added to the flash to create unnatural coloration in the area illuminated by the flash.

IN THE STUDIO

There are three basic options for studio lighting – electronic flash, tungsten and daylight. Flash is by

■ **Below** Flash and tungsten light can be mixed to give variety of colour in the same photograph – this can give the image more character and interest than a perfectly balanced neutral colour throughout. In this portrait of a photographer, flash diffused by an umbrella provides the main lighting from above and to the right. While the modelling lamp from the subject's own studio light adds warmer tones.

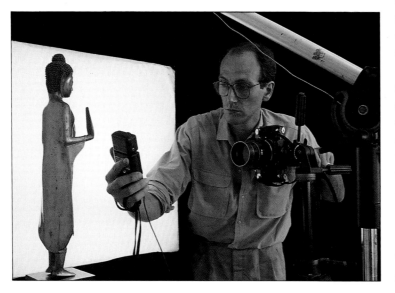

far the most popular and practical, for it freezes movement, which is likely to be vital for any photographs involving models or live creatures. The principal disadvantages of flash are that the photographer is restricted to using the shutter speed at which his camera will synchronize with flash, which may be as low as 1/30sec, and it is more difficult to see in the mind's eye the image that will result, even though flash heads incorporate modelling lights to help set the right modelling balance. Tungsten lighting allows you to see more clearly what the end result will be, but you are saddled with other problems, such as the high temperature generated by the lights and the reduced depth of field resulting from the use of larger lens apertures, since tungsten is not as bright as flash. However, tungsten lamps have the advantage of being much cheaper to buy and install. The photographer can use through-the-lens light metering and any shutter speed, since there are no problems with synchronization.

Daylight appeals to some notable portrait and fashion photographers. The principal advantage is a naturalistic, uncontrived appearance to portraiture, although this is sometimes achieved at the expense of sharpness because of low shutter speeds/large apertures.

LIGHTING TECHNIQUES

Since basic, direct flash can be harsh and unflattering, different types of flash head have been developed to provide diffuse flash. Direct frontal flash is very harsh for portrait photography, for it gives no modelling. The key light is generally positioned above and behind the photographer so that it shines down on the subject, again imitating the sun. Popular sources of key light are the *fish-fryer* and the larger *swimming pool*, which are both high-powered electronic flash *area lights*, designed to give diffused, and hence flattering, illumination. Backgrounds usually need an even source of illumination, and strip lights are the popular choice.

An alternative key light is a conventional flash head, to which can be fitted a variety of attachments to modify the intensity and effect of the flash. These include the ever popular *umbrellas*, in white or silver (also known as brollies or brolly flash); *diffusing filters*; *coloured gels* to warm up, cool down or change the colour temperature of the subject; *barn doors*, a form of hood with four flaps for controlling the direction of lighting; and *snoots*, which are short tubes for firing flash into a small area.

Additional diffusion is achieved by firing flash through large sheets of paper or plastic, or by bringing in *reflectors*. These are panels of various sizes that can be placed around, or to one side of, the subject to reflect back some of the light from the key light. An area light placed to one side of a subject can be used to imitate a window, and a reflector may be needed to fill from the other side. Reflectors can be white polystyrene panels, or hardboard or blockboard panels, which are often painted white one side and matt black the other. A black panel is useful for killing light if one side of the subject is to be in shadow.

■ **Above** Lighting can be inconspicuous – that is, arranged in such a way that it illuminates the subject rather than noticeably contributing to the atmosphere. In this sitting room portrait, three mains flash units were used to produce even, moderately diffused lighting. Two were fitted with white umbrellas and placed to the left and right of the camera. The third was bounced directly off the ceiling to give a top element to the lighting.

■ **Above** A single naked spotlamp was used for this statue of George Washington, positioned on a balcony above. The hard shadows and the localized beam of light produce an intentionally dramatic effect. For a static subject like this, either flash or tungsten light is suitable (although the colour balance of the film must match).

A light table or *scoop* is often constructed to shoot small objects. This consists of a curve of seamless background paper mounted on a table with back support. For shadowless lighting of small objects a photographer can make a light tent out of, say, a cone of tracing paper, which is placed over the object on a table. Objects can be made to appear to defy gravity if they can be supported by a rod, perhaps inserted through the background of a scoop, on the blind side of the camera. Shiny and reflective subjects are among the most difficult objects to light successfully, but a useful method is to place one or more sheets of translucent plastic between an area light and the subject to provide extra diffusion. Transparent subjects can be lit from beneath by being placed on a sheet of opal perspex, which is on top of an area light.

An indispensable tool for the studio-based photographer is a flash meter. This is used like a light meter to test the lens aperture that should be set for correct exposure. If more than one flash-head is used, the flash meter is invaluable for determining a good balance of key light and fill flash. Readings can also be taken for flash units illuminating the background. A Polaroid test shot, though, will provide the best visual guide to the likely success of the lighting set-up.

ON LOCATION

The term "location photography" can mean anything from shooting cacti in the Arizona desert to taking fashion shots in the streets of London. But in both instances, the sun and the ambient light it creates are likely to be the key light sources. Location photography can also mean photographing interiors or valuable items in a museum, where the photographer will need to reproduce studio lighting techniques without the control available in a studio environment.

Portability will limit the equipment a photographer can take on location, but it will probably

include one or more portable flashguns, a rechargeable power source, synch cables, telescopic stands, one or more tripods, reflectors and, of course, a camera, film and a selection of lenses.

Any additional lighting should not be intrusive when the location itself is the subject or background. Flash, especially fill-in flash, needs to be handled with care. Reflectors are often more popular, since their effect can be seen and the balance more closely controlled.

The time of day is all-important for landscape photography, with the most interesting lighting occurring either very early or very late in the day when the sun is low in the sky and gives lengthy shadows. Colour temperature can change dramatically during the course of a couple of hours in some climates, and this needs to be watched for continuity in reproduction.

Outdoor portraits in bright sunshine can be a problem because of the inherent high contrast. It is best to stand the subject under a tree in the shade or at least with the sun obliquely behind. A giant umbrella, preferably painted black and, held by the photographer's assistant, can be used to shield a subject from direct sunlight.

■ **Left** Backlighting is often used as a means of both injecting atmosphere into a shot and bringing out the texture of shiny surfaces. In the still-life below, two 1000 watt lamps have been aimed through tracing paper covering the window, while a moderately-diffused weaker light above the camera provides shadow-fill.

MANIPULATING
THE IMAGE

THE MOOD AND APPEARANCE of a photograph are by no means fixed when the film is removed from the camera. They can be manipulated in dozens of different ways including cropping and scaling, adjusting development, using special printing techniques, retouching and montaging, and also by little-used effects such as posterization and solarization. Although much can be achieved by the conventional methods described here, image manipulation is increasingly becoming the realm of computerized scanners, such as the Quantel Graphic Paintbox and Scitex machines, which are discussed later.

CROPPING AND SCALING

The most fundamental way in which an art director manipulates the photographic image is by cropping and scaling. When a photograph is taken, in many cases there are areas and spaces that do not contribute towards the composition. This does not mean, of course, that all pictures must depict total activity and that every square inch of the frame must be filled with imagery. Often, spatial relationships require that large areas of a composition be non-active "rest periods", to give weight and emphasis to the main object or figure in a landscape. Powerful, story-telling pictures of drought in Africa or a house in splendid isolation in the Australian outback are examples of this type of stylish and emotive reportage pictures. However, many reasonable pictures become good pictures when they are skillfully cropped.

Movement will often benefit from cropping. Location photography of cars or motorbikes or of a football match will often have superfluous space around the action. When the picture is cropped, the action becomes more relevant, and the tension and excitement are increased. Cropped to a close-up detail, a figure can create a powerful and emotive image. Newspapers have made good use of this process for many years as a way of showing public figures, isolated from their protective backgrounds, in Cromwellian warts-and-all close-up.

To crop an image, you will need a lightbox, a good, powerful, magnifying lens and a pair of L-frames, cut carefully at right angles to form, when put together, a perfect and correct square for viewing the object to be cropped.

Scaling is the method used to enlarge and reduce pictures for reproduction. Two methods are used – a diagonal line from top right to bottom left of the frame, or a reproduction calculator. Process cameras are calibrated by percentage, so sizes using the latter method are shown as a percentage. Whatever method is used, *never* mark the original print. All

■ **Right** Cropping frames are a simple, but essential layout tool for editing photographic prints and transparencies. Used as shown, with one L-frame overlapping the other, they give a clear preview of how a cropped image will look.

■ **Left and above** As photographed, this portrait of an art dealer, used in the brochure on page 97, was square. This was a natural conseqeunce of using a medium-format 6×6cm camera but, of course, a square is one of the least usable image shapes. In this case, the art director took the cropping a step further than simply trimming it to a vertical shape. The light crop at the top and left has produced a framed effect that echoes the theme of dealing in paintings.

■ **Below left and below** Cropping the wine photograph below to create an asymmetrical composition produces a final image that successfully emphasizes the bottle.

sizing should be indicated on an overlay, the position marked with a keyline on the layout.

Cut-outs can be used with good effect to isolate part of the composition to gain attention or to emphasize a point. A figure cut out from its background, for example, can prove a compelling and arresting shape. Another reason for using this technique is if you want to employ a clean white background, dot free, around an object. Use an overlay to indicate to the process house the position you want masked out. It is also easy to mask out an area of the negative by painting out the area concerned with stopping-out liquid. If the shape is a comparatively simple one on a black and white print, it is possible to cut it out with a scalpel blade and re-mount the parts you wish to retain.

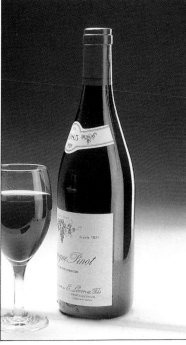

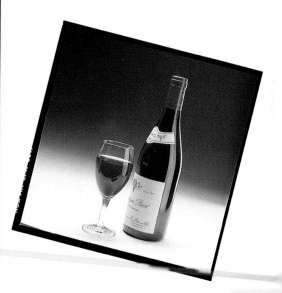

Altering tone and colour

BLACK AND WHITE IMAGES can be printed on paper of differing grades of contrast on a scale from grade 0 (very soft contrast) to grade 5 (very hard, virtually just black and white with no mid-tones). Paper is available either in specific grades of contrast or as a *variable contrast* paper, from which all grades can be achieved by varying filtration on the enlarger.

These different grades originally had the function of making seriously overexposed or underexposed negatives printable – softer grades can salvage overexposed negatives, sometimes at the expense of rich black and clean whites, while harder grades salvage underexposed pictures, at the expense of shadow detail and with a compressed tonal range.

In additional to normal, soft or contrasty, pictures can be printed either *high key*, with predominantly light tones throughout, or *low key*, with predominantly dark, heavy tones. Both methods give a very different feel to the image.

By using techniques commonly called *dodging* and *burning-in*, the printer can adjust areas of a photograph to retain shadow and highlight detail that would be lost in a straight print. By dodging, or holding back light from the area, either with his or her hands or by interposing a dodging stick between enlarger lens and print, the printer can reveal shadow detail that would otherwise block in. Conversely, by burning-in or deliberately giving an area of the print extra exposure, the printer can show highlight detail – such as the features of a face – that would otherwise not show because of the limited exposure latitude of printing paper.

■ **Right** Black-and-white photography offers considerable opportunity for controlling the content and textures of the image. For this beer advertisement, the gritty structure of film grain has been used intentionally: fast, grainy film was used for the shooting, and the grain enhanced by processing in a high-energy developer. This was exaggerated further in the darkroom by printing on to a high-contrast paper, so virtually eliminating highlight and shadow detail.

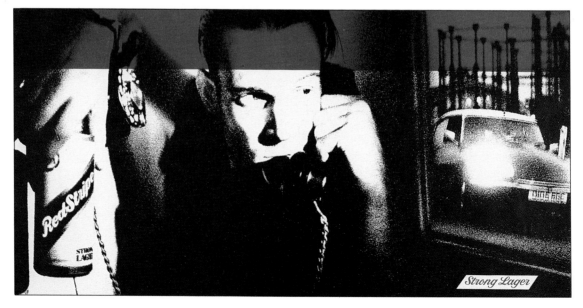

■ **Left** The basic effect of this striking image was achieved in the camera. The model pyramid was raised over the surface of stones and a light aimed up through the opal perspex base (completely covered except directly under the pyramids). Strongly coloured blue and orange gels covered the upper and lower light respectively. A second exposure through a magenta filter recorded a circle of light aimed at the background.

■ **Left** Another method of image manipulation, increasingly popular, is digitalization by means of computer graphics. Once an original image has been entered (by means of a video camera), its tones and colours can easily be altered electronically. Resolution, however, is not particularly good except on the most powerful and expensive hardware.

■ **Above** A straightforward original photograph of rowing boats and pelicans was covered in the darkroom by a process known as tone separation. Lith film, which records only a single tone – black – on a clear background, was used to make a sequence of copies which were then rephotographed on ordinary slide film through strongly coloured filters.

Manipulating the finished print

THE MOST WIDELY PRACTISED METHODS of manipulating a finished black and white print are by retouching, by using baths of toner or dye to add colour, or by hand colouring with dye using a brush. Large format, duplicate negatives and transparencies can also be retouched with a brush, but it is usually better to retouch a print and then re-photograph it to make a new negative or transparency.

Prints may need *spotting*, the term used when a spot of retouching pigment is applied to small white spots caused by dust or tiny airbells clinging to the film during development. Stray hairs and scratches can also be spotted out by using a very fine brush with a perfect point.

Coloured dye can be applied locally by brush to turn a black and white photograph into a coloured one, or to provide a focal point. The print can be bleached and then toned with sepia or a blue toner to change the overall tone of the picture and emphasize highlights, which will stay white and will not be affected by the toner. Colouring dye baths, as distinct from toner, act on the highlights in the picture; the longer the print is left in the dye, the stronger the colour becomes.

The *Sabattier effect* was discovered by accident. It is achieved by briefly re-exposing a partly developed print to light. The highlight areas of the print still contain some unexposed silver halides after the exposure under the enlarger, and the second exposure turns these to metallic silver, resulting in darkened highlights with a silvery sheen. Results are somewhat unpredictable however.

A negative can be printed sandwiched with a *texture screen* negative, which creates an interesting graphic effect and imparts a tapestry-like texture to the photograph. Use of a texture screen tends to soften contrast in the original and may call for a harder grade of paper. It will also appreciably reduce

■ **Right** The basis for this advertising campaign for a wallpaper adhesive is the visual pun of wallpaper being used in impossibly large-scale situations. The wallpaper is real, as is the tree, but the landscape that includes the Great Wall is all illustration. This proved simpler than trying to lay out the wallpaper to fit exactly the convoluted shape of the real Great Wall from an existing transparency.

A GREAT WALL EVERY TIME.

Polycell
All Purpose
Wallpaper
Adhesive
NOW WITH

the sharpness of the details. A texture screen can be made by photographing, say, a piece of fabric or a brick wall and deliberately overexposing by at least three stops.

Colours can be altered and unwanted areas removed and blocks of colour on tone can be matched and extended to make space for text either by chemical processes in the darkroom or, more quickly, by computer. It is also possible to retouch colour transparencies by brush in a similar way to the work done on black and white prints. Stray hairs can be removed and shadows perfected for such meticulous work as car brochures, unwanted signs can be removed from walls, and bottle labels changed – the list is endless, but it all costs money. That money could be saved if the perfect transparency could be produced in the first place, and that calls for great attention to detail in the studio or on the set.

MONTAGING

Sections of two or more negatives can be printed on the same sheet of paper by careful masking between exposures. The art director must have a clear idea of what he or she wants to achieve so that the printer knows precisely how the images are to be montaged and can determine the sequence in which they will

■ **Left** Part of the same advertising campaign as the photograph on the facing page, here the wallpaper was photographed at an angle and in curves to fit London's Albert Hall. The real view was copied with the roof and wall blacked out. The photographed wallpaper was then copied into these black areas.

■ **Above** This combination of images is done in a non-realistic way, which makes the retoucher's work easier. The blending of joins must still be skilful, but it does not have to support an elaborate illusion. As in most transparency retouching, the originals are enlarged when they are duplicated – in this case onto 11 × 14 in film – so that the retoucher's brushwork will not be noticeable in the final print version.

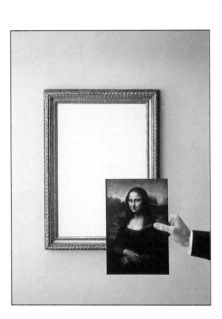

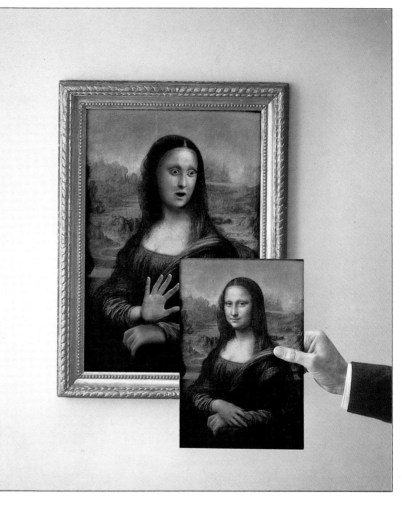

be printed and prepare masks accordingly.

A simple example would be a landscape with a boring, toneless sky. Drama can be added by montaging in a stormy sky from a different negative. The printer makes a print of the first negative and uses it as a stencil to cut one precise, card mask to cover the land section and a second mask to cover the sky section. He places a sheet of paper in the enlarger easel, lays the sky mask in position and prints the land section from the first negative. The sky negative is substituted in the enlarger, the sky mask removed and the land mask placed carefully on the paper for the second exposure.

It is worth noting that images can be combined on the same negative or transparency in the camera, but it is a rather haphazard technique since a precise exposure for the overall image is difficult to achieve, especially when shooting on location. If two images are to be combined, each may need to be underexposed by a half or even a full stop of light. If three exposures are to be made, each may need yet more underexposure. Alternatively, a lens mask can be used to black out a section of the film frame for the first exposure, and a second mask, designed to interlock with the first, is used for the second exposure. This technique allows the same person to be shown twice in the same picture, and images can be mirrored, either in the top and bottom halves of the frame, or to the right and left.

■ **This page** In this skilled demonstration of conventional transparency retouching, the original shot was of a reproduction of the Mona Lisa held in a hand (**top left**). This was enlarged and copied into the picture frame. Altering the face and right hand involved painting skill, but the retoucher employed another trick. Holding back the areas where the new hand and face would be with a lith film mask, the skin area of the chest was copied separately into these positions. This gave him a textured "ground" on which to paint.

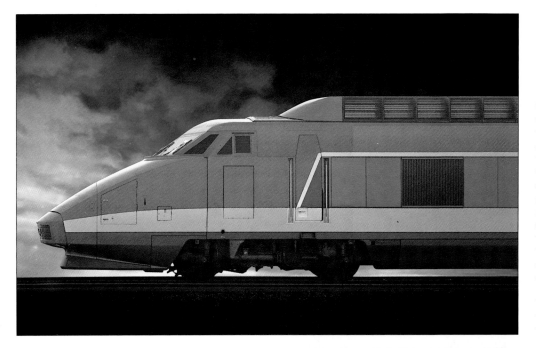

■ **This page** One of the most common demands made on transparency retouchers is to combine two images – in this case a train and sky. The technique used was to make line film masks – silhouettes, both positive and negative – of the train's outline. The positive silhouette mask was then sandwiched with the sky transparency and copied. The transparency of the train, sandwiched with the negative silhouette, was then copied, in exact register, onto the same sheet of film. The final stage was for the retoucher to blend the lines where the two parts of the finished image join.

For multiple exposures without using a lens mask, try to ensure that the area that is to receive detail in the second or subsequent exposure is as near black as possible in the first exposure. This will help to circumvent overexposure of the final image. An SLR camera with a removable prism is ideal, since the different elements of the picture may be traced on the viewing screen to ensure precise alignments.

An example of what can be achieved by conventional means is the Konica UBiX photocopier advertisement that showed the Mona Lisa raising a hand in horror while looking at a copy of herself.

At the other extreme, Electronic Page Make-up (EPM) machines can be used to combine (comp) images such as two or more transparencies, to change colours, to ghost-in one image over another, to change features, to remove unwanted elements in a picture and, if necessary, to change the weather or turn night into day.

Electronic image manipulation

TOMORROW'S GENERATION is being weaned on a diet of imaginative, computerized pop videos and films that use increasingly complex special effects. Advertisers, in consequence, are turning ever more frequently to electronic image manipulation to produce attention-grabbing advertisements, and a transparency may be just the first step on the road to the finished image.

Most EPM machines – Scitex, Crossfield, Hell or Dai Nippon, for instance – are software-based, but the Quantel Graphic Paintbox is hardware-based and much more user-friendly, and it offers the artist greater flexibility. All the machines, however, share a common method of starting work: the transparencies or other visual material that are to be incorporated into the final image or page are electronically scanned onto magnetic tape, which is then loaded into the EPM machine. After manipulation, the

finished work is output onto magnetic tape and journeys back to the repro house for transformation either into colour separations for a page or into a new transparency.

From the art director's point of view one of the great strengths of EPM machines and paintboxes is that he or she can sit beside the operator and oversee the work as it progresses, and just sitting and watching will give you some idea of the tremendous scope and capabilities of the machines.

On machines like the Scitex all instructions are input by use of a keyboard and mouse. The operator moves a cursor, in the shape of a small cross, around the screen to the section that is to be worked on. For example, if an original transparency shows some unwanted element such as a nameplate on a wall, the operator can enlarge this section, draw an electronic line around it to make a mask or stencil, then mask over it by matching the area to the rest of the wall. It does not matter whether the wall is monochrome or brickwork, it can still be done.

Any colour anywhere in the image can be electronically matched with great precision and reproduced anywhere else in the image. Skies can be made bluer, sand yellower; other images can be stripped in to be shown, say, within a circle inside the main image. Images can be tumbled, flipped and rotated at will and basic shape stencils can be stored for use time and again on brochure pages.

The image shown on screen is made up of pixels, rather like the grain in film, which can be enlarged to such an extent that an image can be altered pixel by pixel if necessary – to remove a stray hair from a forehead, for example. But work at high magnifica-

■ **Below** Quantel Graphic Paintbox is one of several systems which allow full electronic combination and manipulation of images, normally performed by a trained operator to an art director's brief. This type of work is costed on time – an experienced operator produced the combined image on the opposite page in one hour.

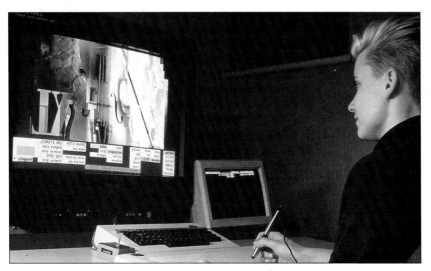

■ **This page** Computerized image manipulation to a standard of resolution suitable for print reproduction needs sophisticated hardware. In this example, two images were perfectly blended using the Quantel Graphic Paintbox system. The first step in the procedure is to enter the original images in the system's picture store. This is normally done by scanning the transparencies in a similar way to a normal reproduction process. Using the computer's cut-and-paste program, a soft-edged version of the traces was positioned over the forest shot. The colours of the track were then matched to the bluer tones of the forest. The two images were then blended, and local contrast details adjusted.

tion is slow and therefore costly – about £300 per hour at the time of writing – and it must, of course, be related to your budget.

Paintboxes, such as the Quantel, are a true designer's tool because the artist/operator can actually paint, mix colours and draw electronically on screen by using a pressure-sensitive light pen. Instead of keying-in formulae, colours can be mixed on the palette like paints. The artist can even select different media, such as thin or thick pencil, or thin or thick brush, to suit the image being created, and this allows great sophistication in combining artwork with transparencies on screen.

The principal drawback of EPM machines at present is the difficulty of producing good proofs. It is an expensive extra stage to provide a transparency for proofing purposes, and a thermal proof is usually the only alternative. These tend to leave much to be desired in terms of definition and colour accuracy, but technology is improving rapidly; software is becoming available that gives a high quality chemical/photographic proof.

A clear understanding of electronic image manipulation will become increasingly important to art directors. Already it is becoming important for the art director to consult the EPM or paintbox operator *before* briefing the photographer, since it may be possible to shoot a transparency in a way that will speed up manipulation and hence save money.

CREDITS

Abbreviations T Top; **B** Bottom; **C** Centre; **R** Right; **L** Left;
PH Photographer; **AD** Art director; **CW** Copy writer.

p 2/3 Hans Neleman (PH), William Scott (AD), Forward Publishing, for Data Logic.
p 6/7 Simon Marshall (PH).
p 8 Simon Marshall (PH).
p 9 T Simon Marshall (PH); BR The Image Bank.
p 10 TR The Image Bank; BL Simon Marshall (PH)
p 11 CL & CR The Image Bank.
p 12/13 Hans Neleman (PH), William Scott (AD), Forward Publishing, for Data Logic.
p 16 Hugh Marshall (PH).
p 17 TL Paul Forrester (PH); BL The Image Bank.
p 18 BL Tim Platt (PH); BC Derry Robinson (PH).
p 19 TL Paul Forrester (PH).
p 20 Paul Forrester (PH).
p 21 L Hans Neleman (PH), William Scott (AD), Forward Publishing, for Data Logic; TC. Michael Harding (PH), William Scott (AD), Forward Publishing, for Data Logic.
p 22 Paul Forrester (PH).
p 23 TL Paul Forrester (PH); BR Reproduced from Guide to Creative Cooking and Entertaining published by Readers' Digest Association Limited, with permission.
p 25 Paul Forrester (PH).
p 29 Paul Forrester (PH).
p 30/31 Hans Neleman (PH), William Scott (AD), Forward Publishing, for Data Logic.
p 32 Daniel Jonnaneau (PH), Steve Dunn (AD), Leagas Delaney, for Harrods.
p 33 TL Barney Edwards (PH), Nigel Rose (AD), Collett, Dickenson, Pearce, for Gallaher Ltd; CR Island Art; BR Argos.
p 34 Argos.
p 35 Habitat, Conran Design Group Ltd.
p 37 TL & TC Paul Forrester (PH); TR, CR, BR & BC Island Art.
p 38 Andrew Sydenham (PH), Pins & Needles, Quarto International Ltd.
p 39 T + CL Bill Batten (PH); Trickett and Webb Ltd; BR Sutton Cooper Ltd.
p 40 BL John Claridge (PH), Collier Campbell Ltd., for Dunhill International; BR Daniel Jonnaneau (PH), Steve Dunn (AD), Leagas Delaney, for Harrods.
p 41 BL John Parker (PH); TR Kevin Summers (PH), Nigel Rose (AD); TCR, Brian Duffy (PH), Graham Watson (AD); BCR Brian Duffy (PH), Alan Waldye (AD); BR John Parker (PH), Nigel Rose (AD); All Collett, Dickenson, Pearce, for Gallaher Ltd.
p 43 Paul Forrester (PH).
p 44/45 Paul Forrester (PH).
p 46 Paul Williams (PH), Louise Kent (AD), Sutton Cooper Ltd.
p 48 Graham Ford (PH), Nigel Rose (AD), Collett, Dickenson, Pearce, for Rank, Hovis, McDougall.
p 49 Anthony Blake (PH).
p 50/51 John Parker (PH), Nick Scott (AD), Richard Spencer (CW), Still, Price, Court, Twivy, D'Souza, for Batchelors.
p 52/53 Gary Bryan (PH), Nick Scott (AD), Richard Spencer (CW), Still, Price, Court, Twivy, D'Souza, for Brook Bond.
p 56 Reproduced from Guide to Creative Cooking and Entertaining, published by Readers' Digest Association Limited, with permission.

p 57 Anthony Blake (PH).
p 58 Ian Howes (PH).
p 59 TR & BR Bob Harris (PH), Wine Magazine, Euro Publishing Ltd; BL Collett, Dickenson, Pearce.
p 60 CL & C Tim Imrie (PH); TR & CR Steven Morris (PH); all for Wine Magazine, Euro Publishing Ltd.
p 61 T & BR The Image Bank.
p 62 BL & TC The Image Bank.
p 63 Paul Forrester (PH).
p 64/65 Paul Forrester (PH).
p 66 Paul Forrester (PH).
p 67 TC & CL The Image Bank.
p 68/69 Paul Forrester (PH).
p 70/71 Paul Forrester (PH).
p 72 Phil Starling (PH).
p 73 TL & CR Phil Starling; B The Image Bank.
p 74 The Image Bank.
p 75 Phil Starling (PH), for Building Magazine.
p 76 Brian Griffin (PH), Peter Devenport (AD), Devenport Associates, for Rosehaugh Stanhope Developments plc and British Railways Board.
p 77 Bovis Homes.
p 78 Richard Bryant (PH), Steven Coates (AD), Blueprint Magazine.
p 79 TL & BL Bill Batten (PH), Trickett and Webb Ltd; CR & BR Habitat, Conran Design Group Ltd.
p 80 BL The Image Bank; BR Christopher Ridley (PH), Roundel Design Group, for Rail Freight.
p 81 T Eric Mandel (PH), Brooks and Vernons, for JCB Sales Ltd; BL Christopher Ridley (PH), Roundel Design Group, for Rail Freight; BR The Image Bank.
p 82 Ian Dawson (PH), Adam Stinson (AD), Car Magazine.
p 83 TL & CL Ford; CR Mervyn Franklin (PH), Adam Stinson (AD), Car Magazine.
p 84/85 86/87 John Miller (PH), Joy Hanington (AD), Homes and Gardens.
p 88 BL & BR The Image Bank.
p 89 T Glynn Williams (PH), Trickett and Webb Ltd; B Don McCullin (PH), Neil Godfrey (AD), Neil Barstow (CW), Collett, Dickenson, Pearce, for the Metropolitan Police.
p 90 MOT Model Agency.
p 91 T Andreas Heumann (PH), Zelda Malan (AD), Saatchi and Saatchi, for Lanson; B Peter Lavery (PH), Nick Scott (AD), Richard Spencer (CW), Still, Price, Court, Twivy, D'Souza, for the Royal College of Nursing.
p 92 Sarah Hutchings (PH), Pins and Needles, Quarto International Ltd.
p 93 CR Gered Mankowitz (PH); B Gered Mankowitz (PH), Dion Hughes (AD), Simon Brotherson (CW), Still, Price, Court, Twivy, D'Souza, for Warburton's.
p 94 Russel Young (PH), Jeremy Leslie (AD).
p 95 T Phil Starling (PH); B Eric Gauster (PH), Jeremy Leslie (AD).
p 96 Glynn Williams (PH), Trickett and Webb Ltd.
p 97 Frank Herholdt (PH), Sutton Cooper, for Thos. Agnew & Son.
p 98/99 The Image Bank.
p 100 T & CL & BR The Image Bank.
p 101 John Swannell (PH), Pete Gatty (AD), BMP Davidson Pearce, for Rimmel.
p 102 C Norman Parkinson (PH), Martyn Walsh (AD); BC & BR

Uwe Ommer (PH), Martyn Walsh (AD).
p 103 Joyce Tenneson (PH), Martyn Walsh (AD).
p 104 Stephane Sednaoni (PH), Elizabeth Djian (AD), The Face.
p 105 T Stephane Sednaoni (PH), Elizabeth Djian (AD), Phil Bicker (AD), The Face; B Jean Baptiste Mondino (PH), Elizabeth Djian (AD), Phil Bicker (AD), The Face.
p 106 TL & TC & TR Sarah Hutchings (PH), Pins and Needles, Quarto International Ltd. BR Michael Roberts (PH), Dorothy Anne Harrison (AD), reproduced from Tatler © Tatler Publishing Ltd.
p 107 John Claridge (PH), Sutton Cooper, for Dunhill International.
p 108/109 Tony McGee (PH), Cosmopolitan.
p 110/111 Tony McGee (PH), Cosmopolitan.
p 112 Witold Krassowski, The Independent.
p 113 L The Image Bank; BR Witold Krassowski, The Independent.
p 116 Ashwin Metha (PH), Connell, May and Steavenson, for the India Tourist Board.
p 117 T Ashwin Gatha (PH); Connell, May and Steavenson, for the India Tourist Board; CL & CR Trevor Seaward (PH), Mark Griffin (AD), Young and Rubicam, for Jamaica Tourist Board.
p 118 The Image Bank.
p 119 TL & TR Christian Thompson (PH); Phil Bicker (AD), The Face; B The Image Bank.
p 120/121 David Keegan (PH), Dorothy Ann Harrison (AD), reproduced from Tatler © Tatler Publishing Ltd.
p 122/123 Hans Neleman (PH), William Scott (AD), Forward Publishing, for Data Logic.
p 124 Michael Freeman (PH).
p 125 Paul Forrester (PH).
p 127 Michael Freeman (PH).
p 128/129 Michael Freeman (PH).
p 130 Paul Forrester (PH).
p 131 TL & TC Frank Herholdt (PH); Sutton Cooper, for Thos. Agnew and Son; BC & BR Paul Forrester (PH).
p 132 Ian McKell (PH), Rick Ward (AD), Jenner Keating Becker Reay.
p 133 The Image Bank.
p 134 Ken Griffiths (PH), Nigel Rose (AD), Chris Street (CW), Collett, Dickenson, Pearce.
p 135 B Ken Griffiths (PH), Nigel Rose (AD), Chris Street (CW), Collett, Dickenson, Pearce; T Jones Bloom Photographic.
p 136/137 Jones Bloom Photographic.
p 138/139 Quantel Ltd.

Quarto would like to thank the following for contributing additional editorial material for this book: Donald Cassell, Michael Freeman, Gavin Hodge, Lynne Pembridge.

With special thanks to Mark Gandy at Image Bank.